MW00366026

KIBWORTH
THROUGH TIME
Stephen Butt

AMBERLEY PUBLISHING

First published 2011

Amberley Publishing
The Hill, Stroud
Gloucestershire, GL5 4ER

www.amberley-books.com

Copyright © Stephen Butt, 2011

The right of Stephen Butt to be identified as the
Author of this work has been asserted in accordance
with the Copyrights, Designs and Patents Act 1988.

ISBN 978 1 4456 0386 5

All rights reserved. No part of this book may be
reprinted or reproduced or utilised in any form
or by any electronic, mechanical or other means,
now known or hereafter invented, including
photocopying and recording, or in any information
storage or retrieval system, without the permission
in writing from the Publishers.

British Library Cataloguing in Publication Data.
A catalogue record for this book is available from
the British Library.

Typeset in 9.5pt on 12pt Celeste.
Typesetting by Amberley Publishing.
Printed in the UK.

Introduction

One person cannot write the history of a village. It is written by the people who live in it and have lived in the village in the past, and it is recorded by official records, legal documents and family heirlooms.

The history of the villages of Kibworth Beauchamp, Kibworth Harcourt and Smeeton Westerby is well-documented over many centuries, mainly because of the interests of Merton College in Oxford. In the nineteenth century, three fine local photographers added to that heritage by leaving a strong visual record of the area. Their work is included in this book.

These photographers were Walter Bale, who was based at one time in High Street, Kibworth Beauchamp, and worked mainly during the first four decades of the twentieth century, Alonzo Freeland, who, with his wife and family, settled in Kibworth in 1886 to continue his professions as pharmacist, analytical chemist and dentist, and Charles Cooper, one-time sub-postmaster in Kibworth, stationer and publisher.

This is not the first published record of this area by a member of my family. In 1916, an ancestor, Francis P. Woodford, wrote his *History of Kibworth and Personal Reminiscences.* His book still provides vital information about the families and buildings of the time. Woodford was prompted to set down his memories by the publication of G. W. Barratt's *The History of Ancient Kibworth* in 1910.

In addition, the clarity of our understanding of the history of the Kibworth villages is due in no small part to the diligent and energetic work of the late Bert Aggas. Bert was not only a local historian, but a good archaeologist, and seemingly a man of unbounded enthusiasm for recording, with accuracy, the changing history of the area. I wish I had known him. A number of his many images are included in this volume with full acknowledgement of his excellent research methodology and his sheer enthusiasm.

Kibworth has often been perceived as being separate communities divided by the A6 main road from Leicester to Market Harborough and by certain vague local rivalries. Hopefully, this view was effectively changed by the BBC television series *Story of England*, presented by Michael Wood, and first broadcast in 2010.

These programmes were ground-breaking because the production company took time to work with the people of the villages to write their history in a way that has never previously been attempted by the media.

There is no one history. Each of us is not only a part of history, but has our own unique history, and our own interpretation of our past. This book was completed while villagers were completing their 2011 Census forms. By the time we reach the next Census, I hope this book will be a part of our history.

Acknowledgements

This volume has been made possible by the assistance of the Kibworth History Society and the inclusion of material from their extensive collection. In particular I must acknowledge, with gratitude, the guidance of George Weston and Norman Harrison, but I need also to thank all those members of the society who have offered their knowledge and memories. Philip J. Porter's books, in which he takes readers on a 'stroll down memory lane' through Kibworth and Smeeton, are a valuable and reliable history of this area.

The photograph of the 1905 Leicester Unemployed March is reproduced by kind permission of the Record Office for Leicestershire, Leicester and Rutland. The aerial view of the former Gents Factory is taken from Colin Reynold's history of the company, published in 2005.

I have also drawn upon research undertaken by Norman Vine, Pam Aucott, Steph Mastoris, Arthur Cossons and Bernard Elliott.

Many local people have guided me to locations across the three villages, and provided helpful background material. In particular, I would like to record the valuable information provided by Jane and Roland Smith who took time to look through my preparatory papers, and to every local person who has allowed me to invade their property and privacy in order to record the images of today.

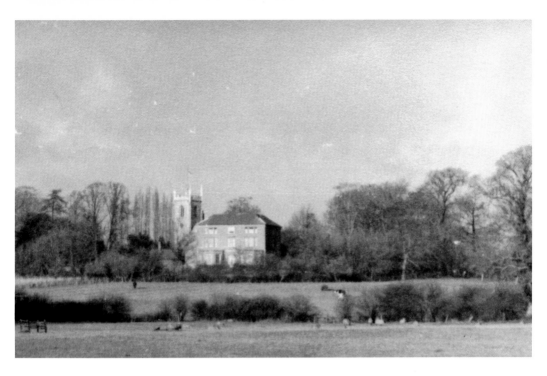

St Wilfrid's Parish Church and the Old Rectory
The old rectory was built in 1788, and demolished when the present Rectory Fields estate was built. It replaced an earlier rectory which stood near to the site of the railway station.

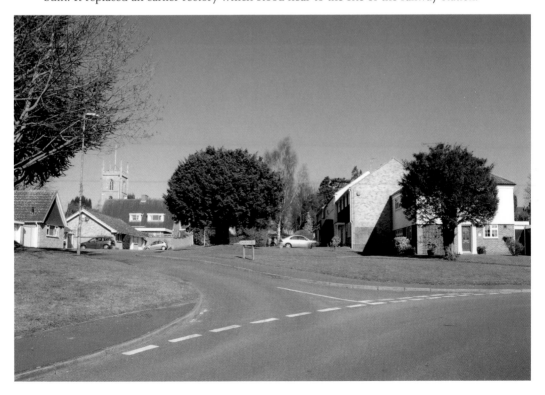

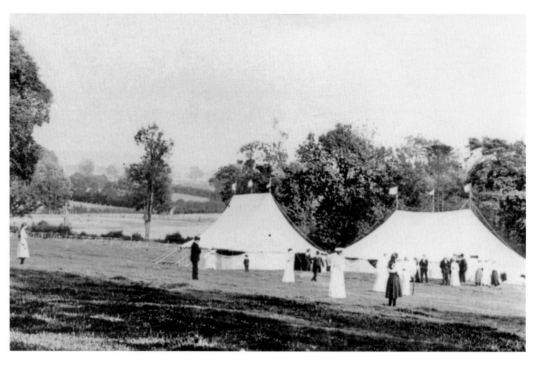

Kibworth Beauchamp Flower Show, 1909
The famous Kibworth Flower Show on the Rectory Field photographed in 1909 by Walter Bale. The location is between Rectory Lane and The Lea, looking south towards the brook running between The Lea and Rookery Close.

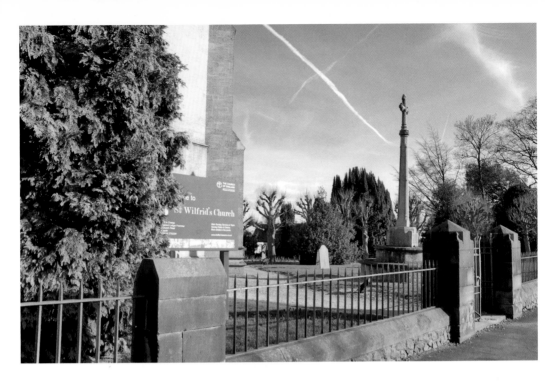

The Bells of St Wilfrid's

There were six bells before the collapse of the spire in 1825. The treble bell was damaged in the incident and recast, and two further bells and an iron frame were added in 1904. The oldest bell dates from 1618. The bells ring out every Wednesday evening during practice sessions and on Sundays and special occasions.

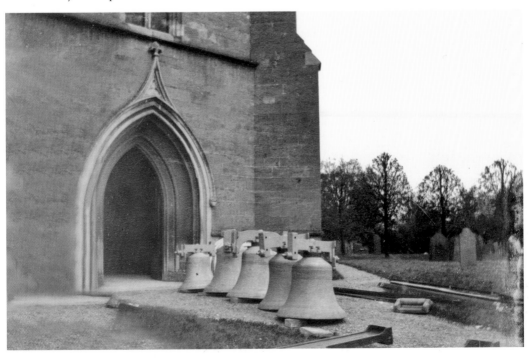

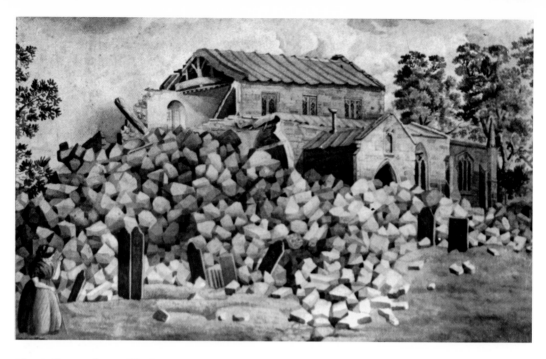

The Collapse of St Wilfrid's Spire 1825
The slender spire of the parish church fell down on 23 July 1825. Local artist James Smeeton (1781–1868) recorded the devastation. The rector, James Beresford, was careful not to allocate blame, but it seems that neglectful restoration work at the time contributed to the collapse.

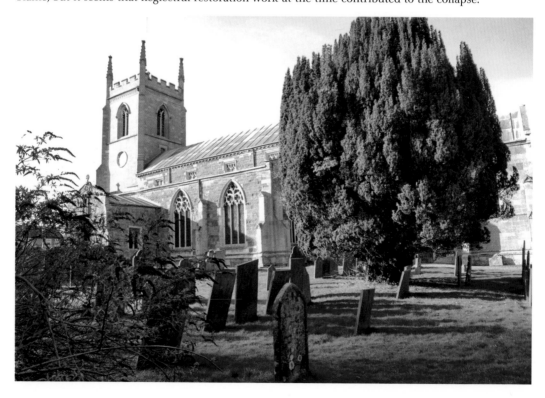

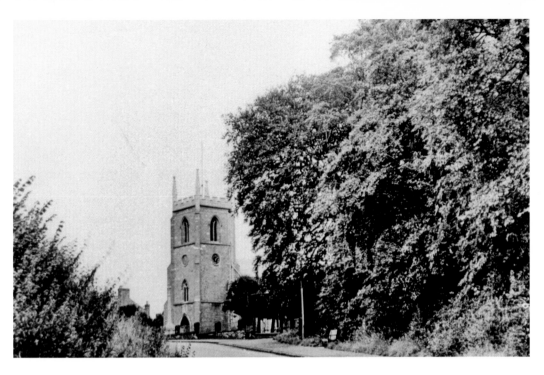

St Wilfrid's Parish Church from Church Road
It took six years to replace the collapsed spire with a new tower. The church stands close to the parish boundary between Beauchamp and Harcourt. In the past, its separate entrances emphasised the distinction between the two communities; today, the church draws worshippers from both villages and the wider area.

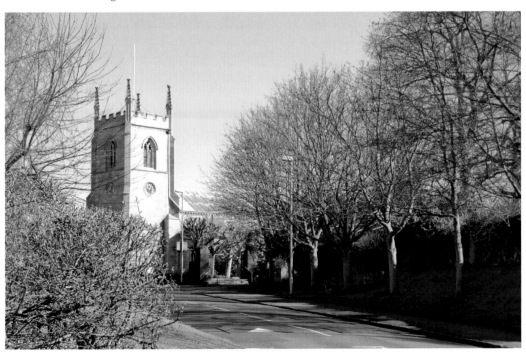

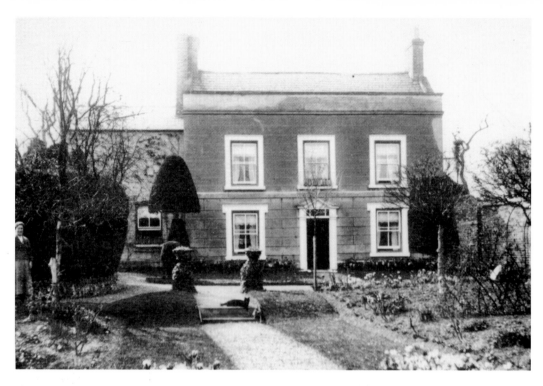

The Grey House, Church Road
A Grade II listed building built in the eighteenth century and re-modelled in the nineteenth century. The house seems to hide behind its iron railings and magnificent garden, tended at one time by a distinguished horticulturalist, Mr Charlton, who for a time was responsible for the village's popular Flower Show on the Rectory Field.

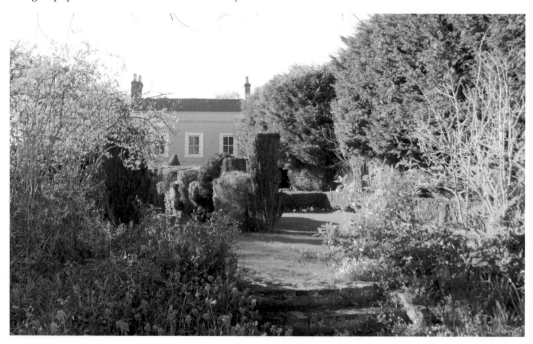

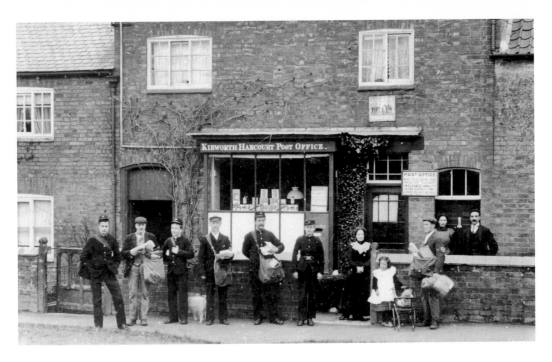

Kibworth Harcourt Post Office, 33 Church Road
The sub-postmaster, Charles W. Cooper, and his staff, taken in about 1905. This was Kibworth's second post office, and a few years later Cooper moved to Beauchamp's third post office at 17 Station Street. Cooper (1865–1926) was a fine photographer, and some of his work is included in this book. He usually worked with fellow-photographer Alonzo J. Freeland and frequently both their names appear on local photographs.

Church Road Shops

There was formerly a cluster of little shops next to the church. By 1908, the Kibworth and Great Glen Cycle Motor Store had moved in to 33 Church Road, and No. 37 was a grocery shop. In F. P. Woodford's time, stonemason and builder William Thompson lived next to the church; Mr Goodale, the chemist, lived next door.

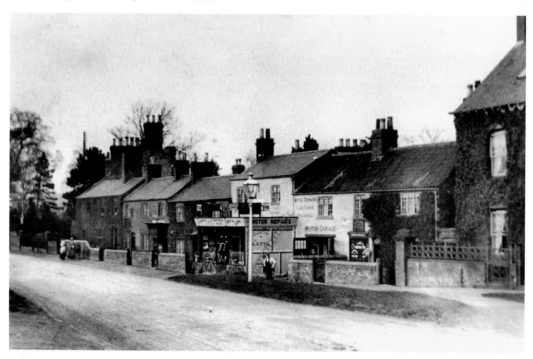

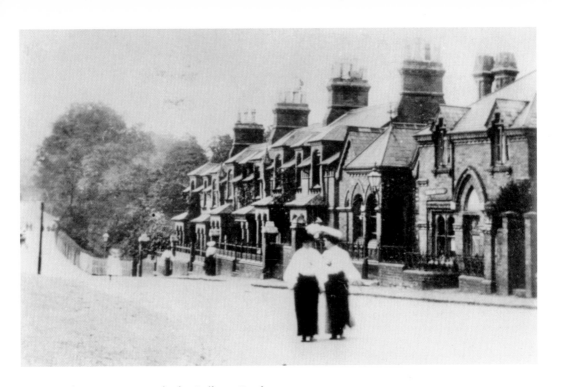

Station Street towards the Railway Station
Kibworth Beauchamp's third post office once occupied No. 17, next to the village hall which was built in 1866. No. 17 is now the Market Harborough Building Society. The terrace known as Beauchamp Cottages was built by the family of local builder John Mason.

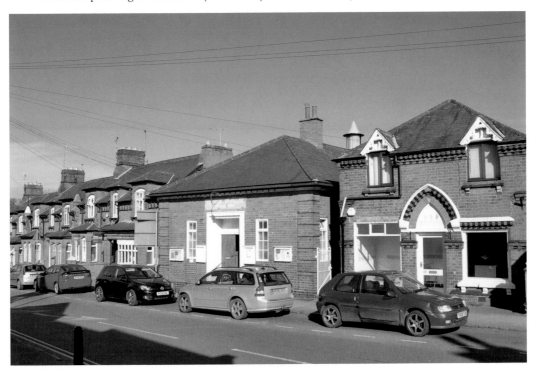

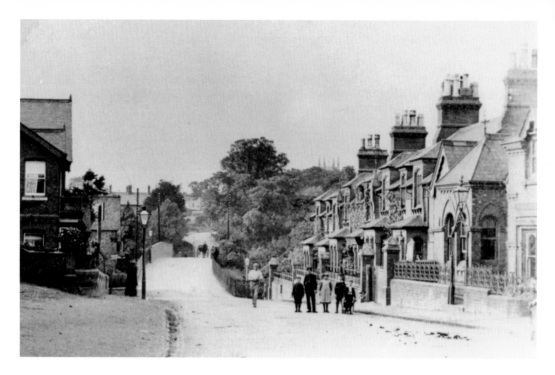

Beauchamp Cottages, Station Street
No. 23 Station Street was Kibworth's first telephone exchange from where the National Telephone Co. Ltd operated in the early years of the nineteenth century. Before the railway was constructed, the road dropped sharply into the valley before rising up towards the church.

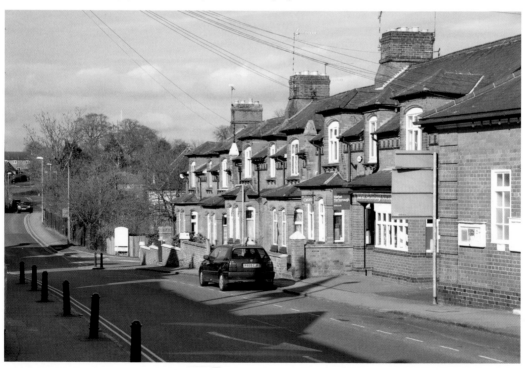

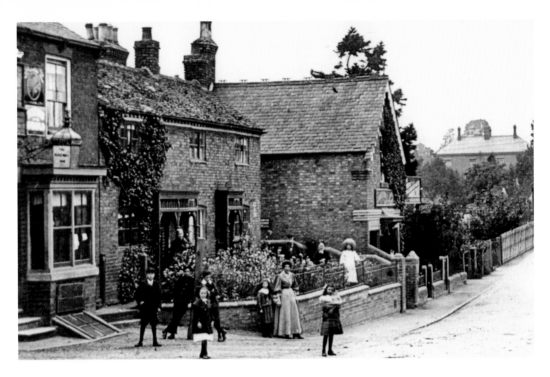

The Railway Inn and Freelands Chemists

The original inn had been altered several times, and was replaced by the present building in 1926. The three cottages were demolished at that time. Part of the original walls and buttresses along the side of the Turnstiles footpath, between the pub and the chemists, have survived.

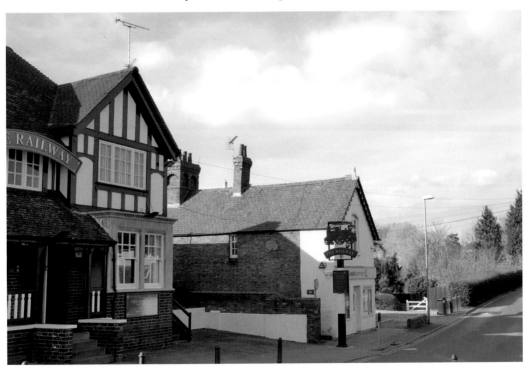

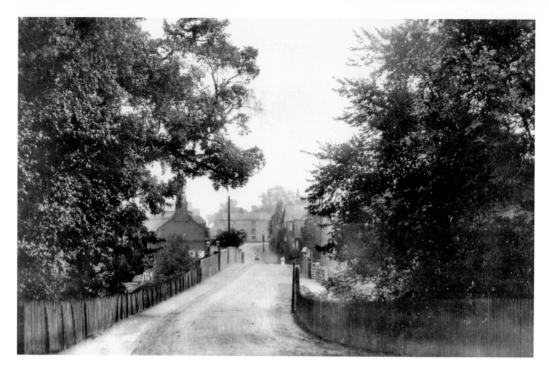

Church Street

The Railway Inn and The Bank can be seen in the distance, over the railway bridge. Originally, the walls of the bridge were just 3 feet high. They were raised in 1875 following many complaints about horses being frightened by the steam from trains passing below.

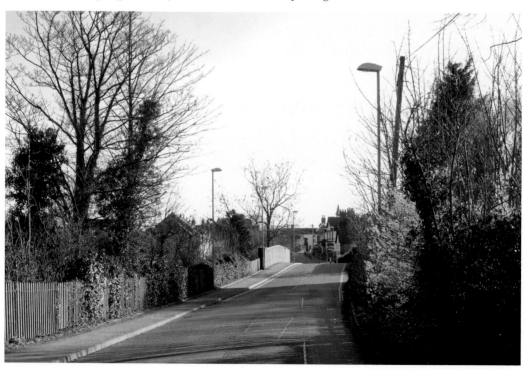

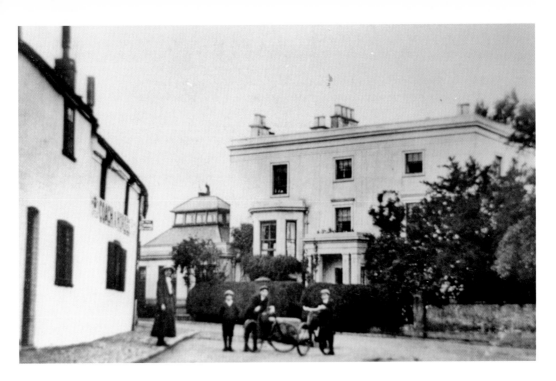

Harcourt House
Standing opposite the Coach and Horses, Harcourt House was the residence at one time of an influential surgeon, Dr John Marriot and was demolished in 1937. The houses and shops which are today's Harcourt Estate stand in its place and on its former land.

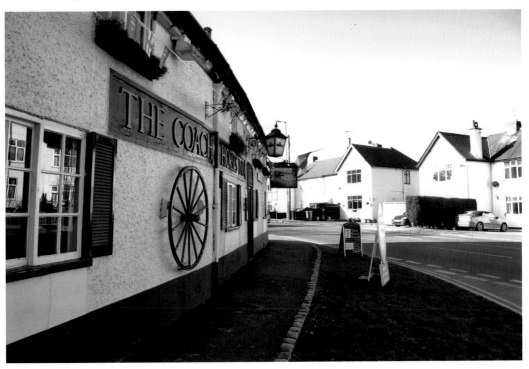

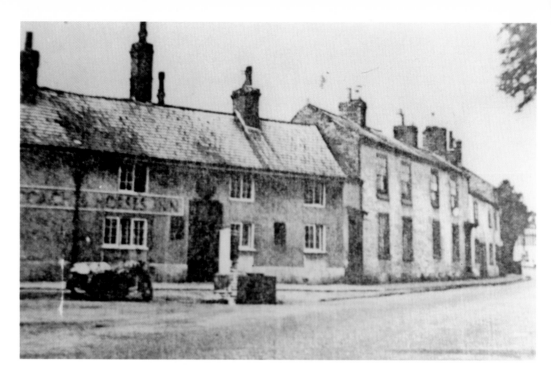

The Coach and Horses, Leicester Road

The Whitsuntide Village Feast was held here at one time, and a member of my family, Henry Woodford, was the landlord in the late nineteenth century. The original inn dates to the seventeenth century. A long wooden horse trough stood in front of the inn for many years, in which local boys sometimes sailed paper boats and other items, and where, on certain occasions, a drunken brawler was ducked in order to cool off.

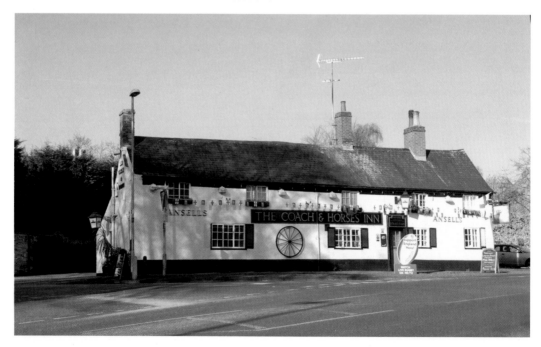

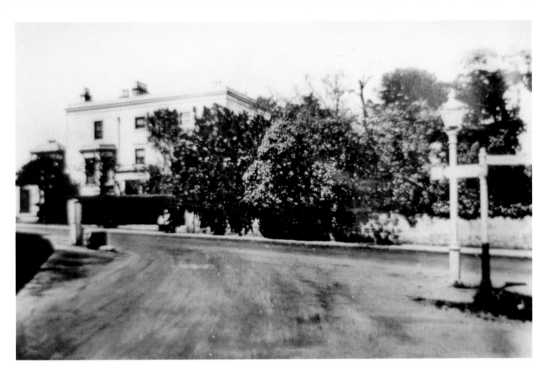

Church Road and Marsh Drive

To the right of the signpost is the turning into Marsh Drive. This was a gated lane known as Marsh Lane until 1937. The lane joined the A6 Leicester Road near to where the trees stand in the older photograph.

Hillcrest Avenue

The Hillcrest Avenue estate, containing nearly 150 houses, was laid out after the Second World War, partly to provide housing for returning servicemen and their families. The school was built in 1959.

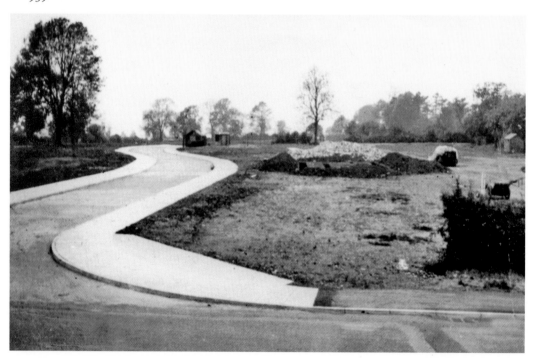

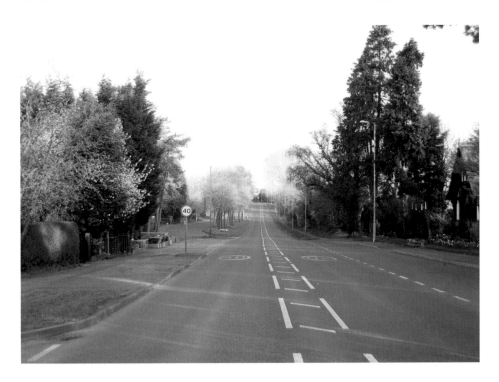

Rector's Plantation, Leicester Road

The lay-by was formed when the road was straightened. The original double bend provided a manageable gradient to this point, where the brook crosses the road. Accidents were frequent at the sharp bends through the village. One man, Michael Ingo, aged seventy-three years old, was killed when an express coach overturned nearby at about midnight on 21 April 1834. There is a slate to his memory in the churchyard.

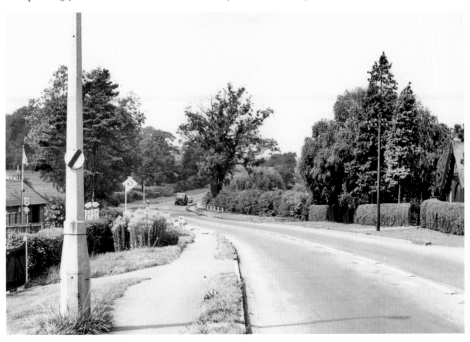

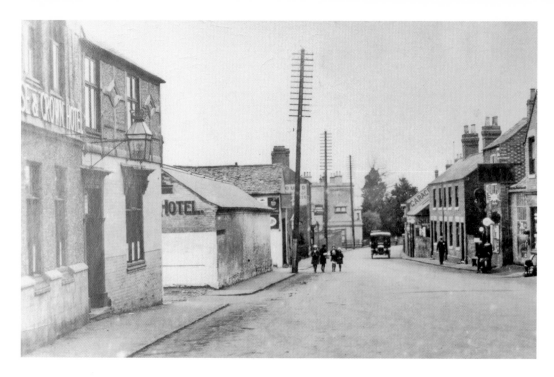

Leicester Road from the Rose and Crown

There is a distinctively village feel in the early photograph of the A6 Leicester Road looking towards the Marsh Drive and Church Road junction from the Rose and Crown, which was taken in about 1925. On the right is the Kibworth Motor Garage which was possibly the first in the villages to have a licence to sell petrol.

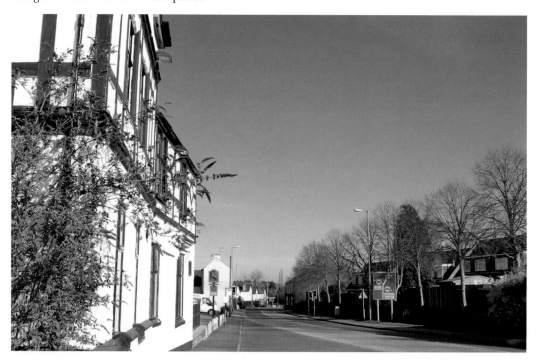

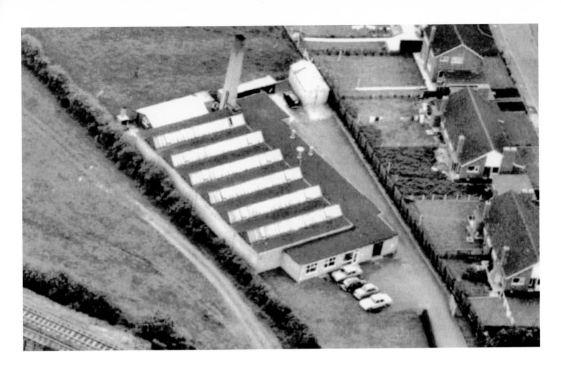

Gents Factory

The former Gents Factory with the railway line on the left and The Fairway on the right. Gents of Leicester made finely-engineered timepieces for industry, hospitals and schools. The factory opened in 1961, the workforce moving from smaller premises on Leicester Road. The Parsons family, who owned and managed the business, had its roots in Kibworth. The factory is now a motor repair garage.

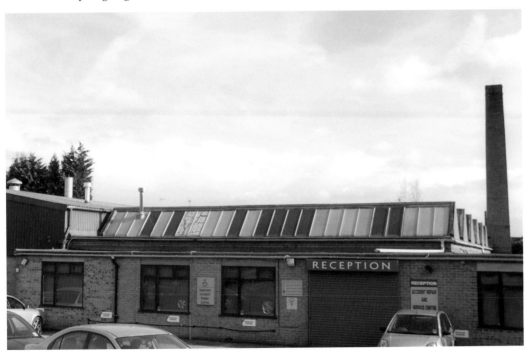

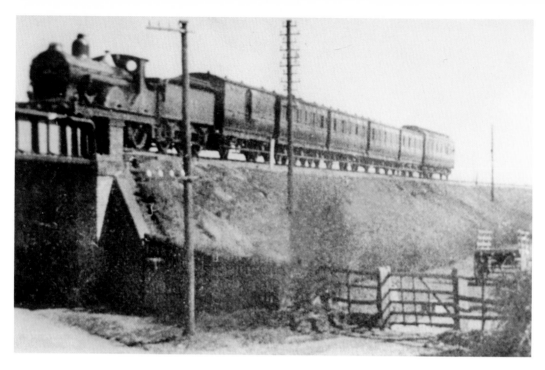

New Road Railway Bridge

A passenger train passes through Kibworth, crossing over the New Road railway bridge in about 1910. The bridge was replaced in 1915 by a new structure with higher parapets. The line opened in 1857, with through trains operating into Kings Cross in the following year. The route to St Pancras opened eleven years later.

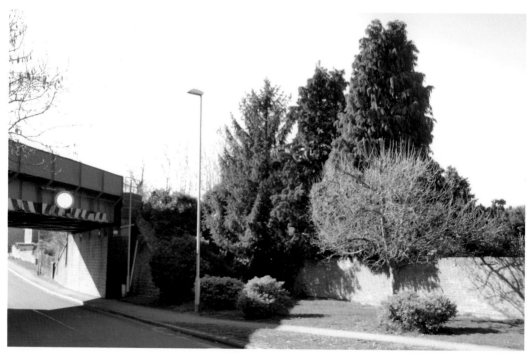

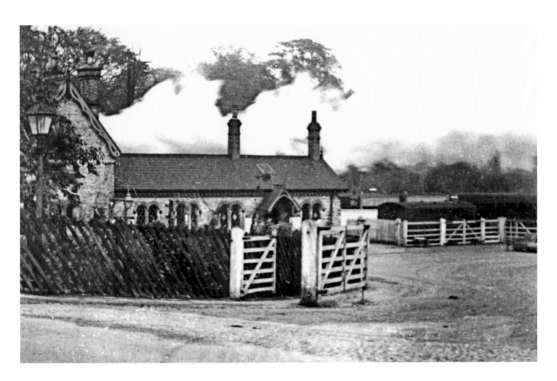

Station Approach

The approach to the railway station, guarded by white gates, is now the entrance to a small residential area created within the station yards, called Isabel Lane. The station building is a fine example of a comparatively unaltered design of its time.

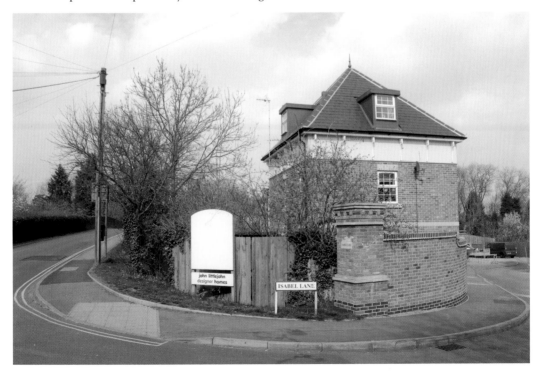

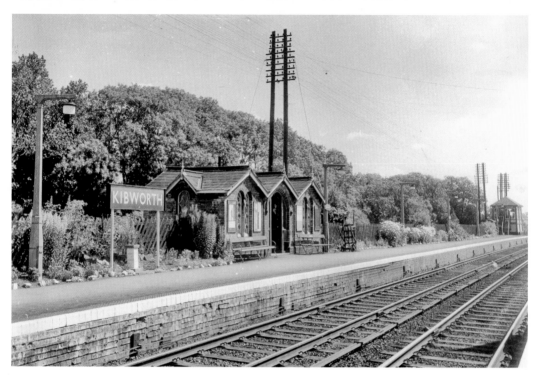

Railway Station Up Platform
Sir John Betjeman would surely have waxed eloquently at the simple elegance of the buildings. Behind the trees is the Rookery Close play area.

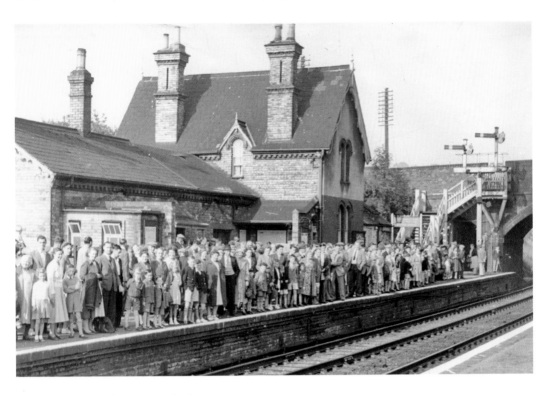

Railway Station Down Platform
The station was built in what has been described as 'Midland Ecclesiastical Gothic' style, using yellow brick with red and blue brick dressings. Happily, it has survived the neglect of more than forty years since it closed on 1 January 1968.

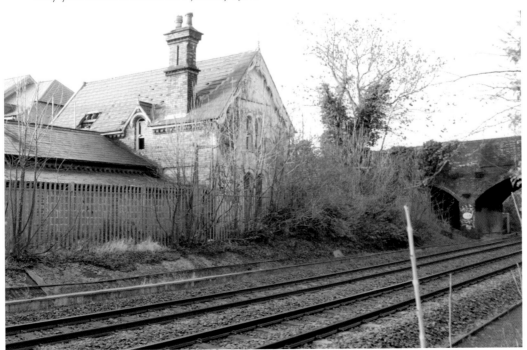

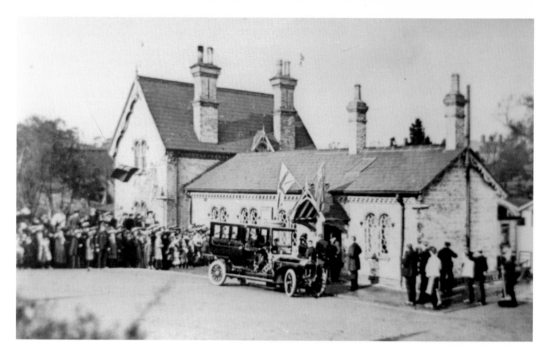

A Royal Visit to Kibworth
The Duke of Argyll and Princess Louise, Queen Victoria's fourth daughter, visited Kibworth on 7 November 1907. They had married in 1871. The Duke died in 1914. The 'Midland Ecclesiastical Gothic' can be seen clearly in the design of the windows. The stationmaster lived in the building on the left. The station was rebuilt in 2011.

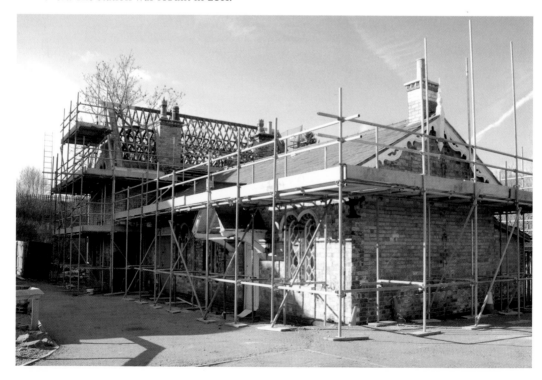

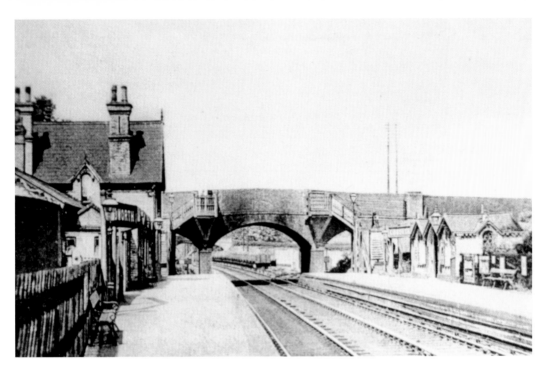

Railway Station towards Church Road Bridge

A tranquil scene that shows how well the railway architecture suited the rural landscape. The wooden steps can be seen on either side of the bridge, giving access for passengers to the platforms. Although the platforms were removed some years ago, the station building has survived and, in 2011, was being given a new slate roof.

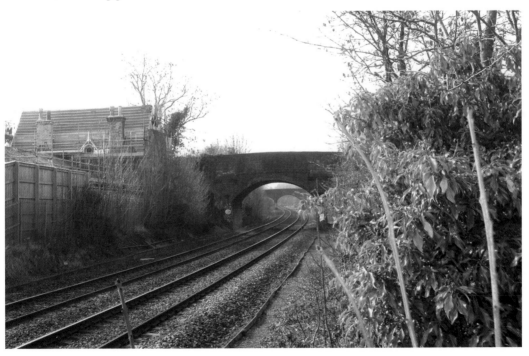

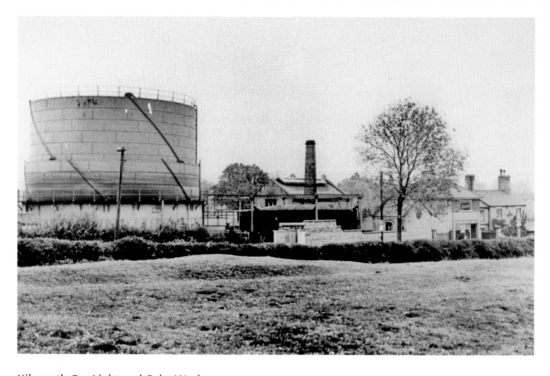

Kibworth Gas Light and Coke Works
Kibworth's gasworks as seen from what is now Links Road. Gas lighting came to Kibworth in 1862, the location of the works being influenced mainly by the proximity of the railway line by which coal was delivered.

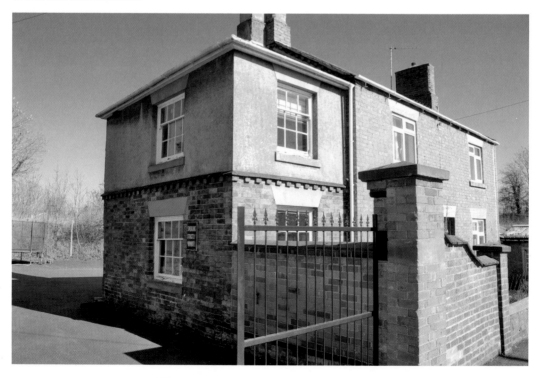

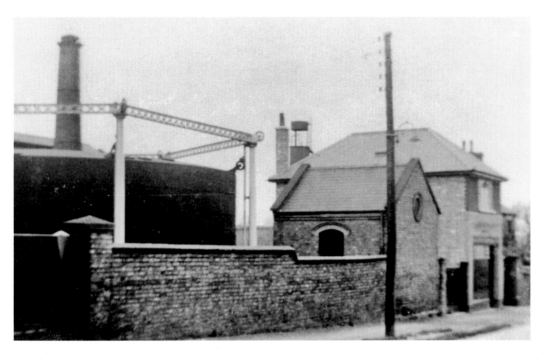

Kibworth Gas Light and Coke Works
The original office building of the gas company still stands and is a private residence. Most of the site is now occupied by the Kingsley Business Park, home to several local innovative businesses.

31

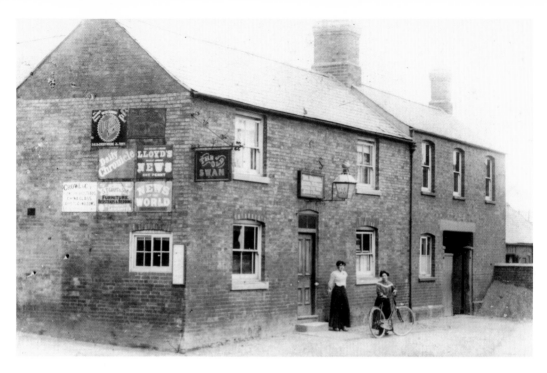

The Swan

The Swan is no longer the 'old Swan', but it has been an inn since the early 1800s. The extension was built in 1873, and the porch and bay windows in 1926. The pub was given a further facelift in early 2011.

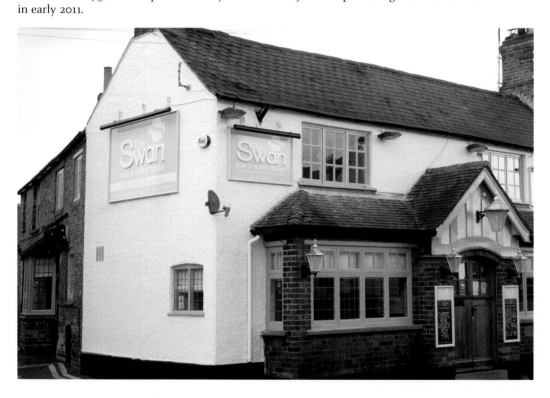

Weir Road I

A picture by local photographers, Freeland & Cooper. The building on the right was originally the livery and posting stables owned by F. A. Boniface. The building to its left was another of Kibworth's inns, its name long forgotten, since it closed in about 1870. Weir Road is also known locally as Music Street.

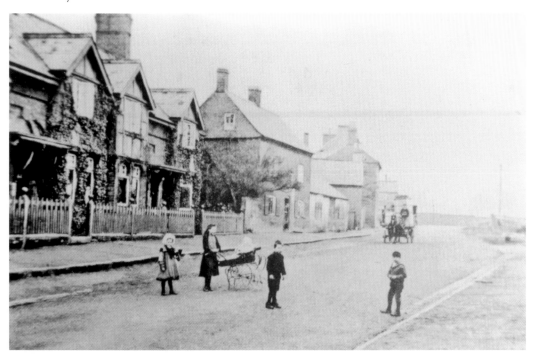

Weir Road II
Weir Road in about 1903 and not long after its name had been changed from Weir Lane. In the distance are open fields and the weir, known locally as the 'Floodies'. Part of this end of Weir Road was known as 'Barrack Yard' because a group of retired soldiers lived in a block of cottages around a square adjacent to the road.

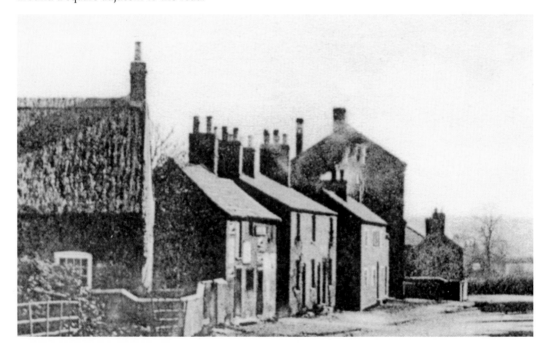

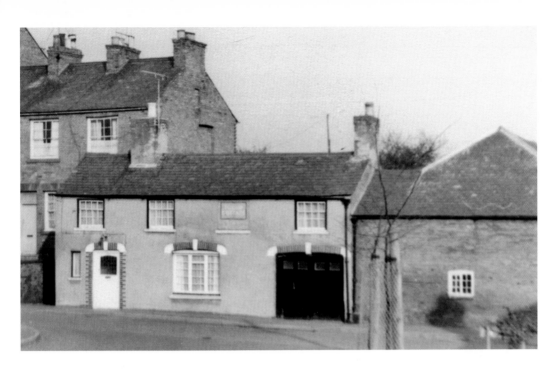

Tudor Cottage, Weir Road

The building known today as 'Tudor Cottage' speaks of its origins in an embossed stone on its frontage, but it was originally two cottages. The four windows on the upper floor may be in their original places, but the door and ground floor windows have moved. Behind this house in 1954, the skull and other bones of a large ox were discovered.

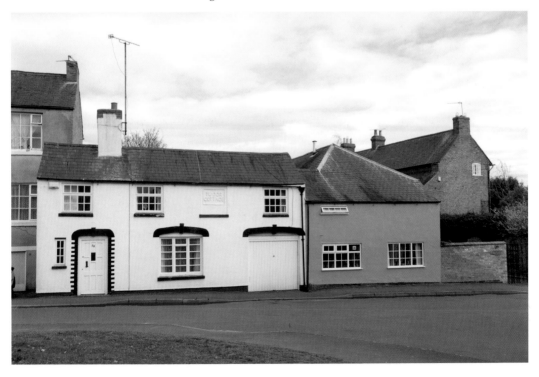

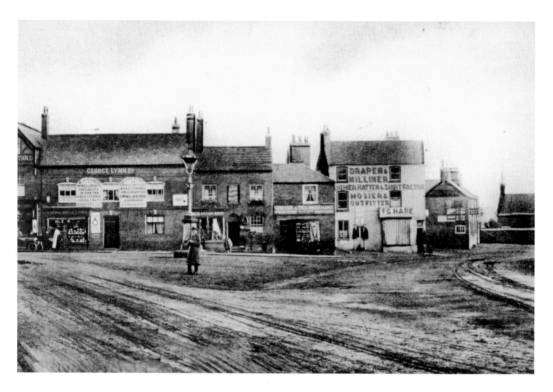

The Bank

The heart of Kibworth Beauchamp was, in earlier times, known as Cross Bank. A market cross once stood here, and in 1221 Henry III granted Walter de Beauchamp a licence to hold a Monday market. A statute fair, known locally as the *statis*, was held here during the nineteenth century.

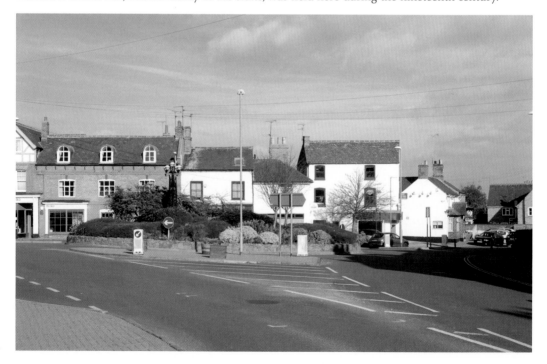

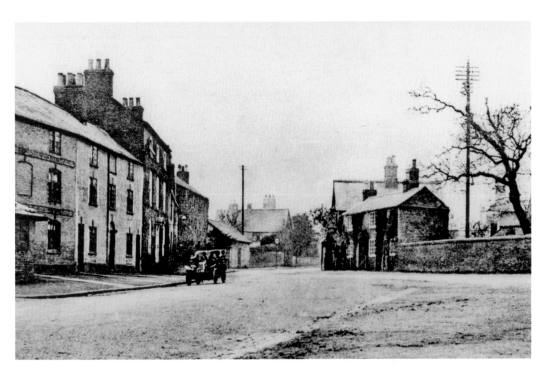

The Bank and High Street
The view towards High Street in about 1905. Two years later, the Council Infant School would be built on the land behind the low wall.

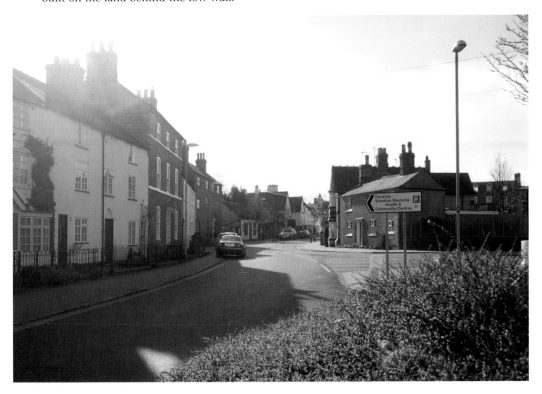

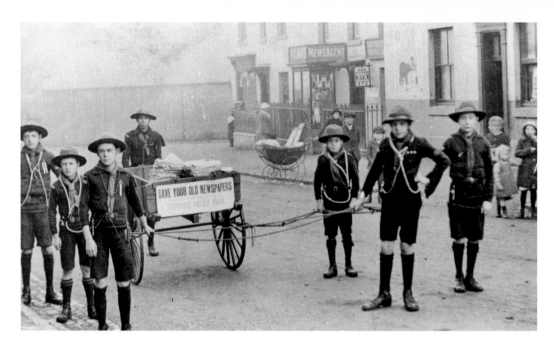

Scouts and the War Effort

Local scouts collecting in High Street for the National Relief Fund in 1916. This photograph dates to the earliest years of scouting in Leicestershire. The Leicestershire Scout Council had been formed in 1910, when Lord Baden-Powell visited Leicester. In 1914, one thousand scouts were mobilised around the country to act as messengers and lookouts.

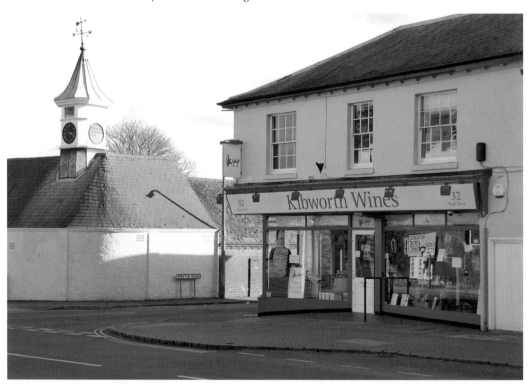

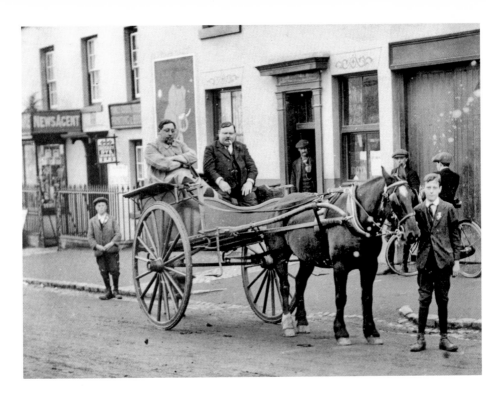

Beefy Berry in High Street

The location is the same as in the previous photograph. Mr Berry perhaps gained the nickname of 'Beefy' not only account on his size, but also because he was the village butcher. His shop is now 10 Main Street in Kibworth Harcourt. This end of Main Street is still known as 'Berry's Hill' by older residents. The shops in Beachamp's High Street are still trading.

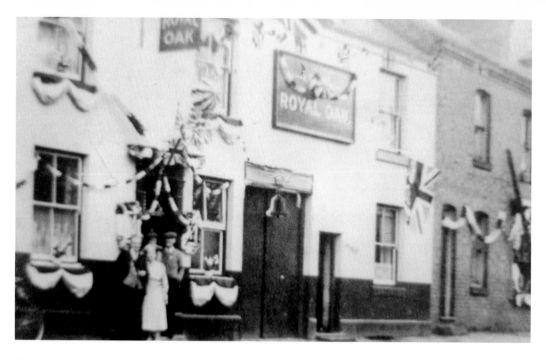

The Royal Oak

The Royal Oak in High Street in 1937, at the time of the Coronation of King George VI. All old inns have stories to tell. F. P. Woodford claimed that Charles Blondin once walked across High Street on a tight rope suspended from the roof of the Royal Oak.

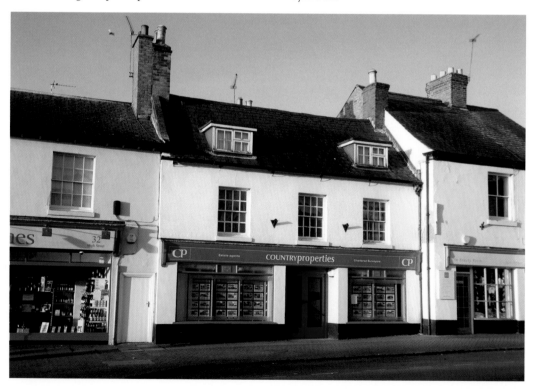

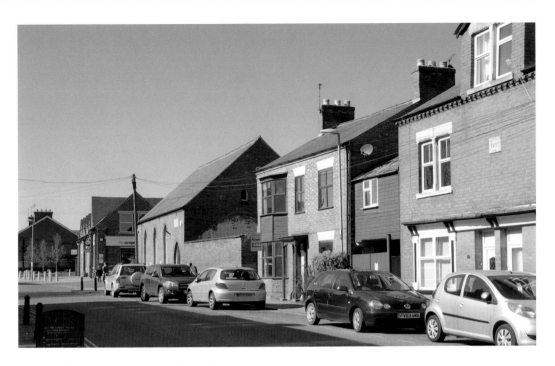

High Street towards Fleckney Road

On the right, behind the children, is the former Baptist Hall, used by the Baptists between 1825 and 1924. It was built by W. W. Underwood who lived at Beauchamp House, where the Baptists had previously held their meetings, and later used as a parish hall for St Wilfred's.

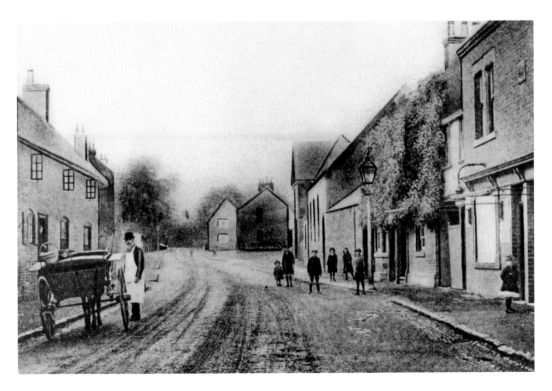

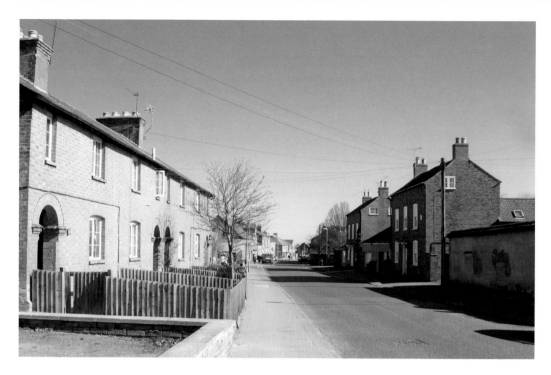

High Street towards The Bank
A familiar view to all Kibworth residents. Set back on the left is Welton's Farm, which was demolished when the present Co-op store was built. The store's frontage reflects the architecture of the old farmhouse. The name lives on in 'Welton Close', a recent development off Meadowbrook Road.

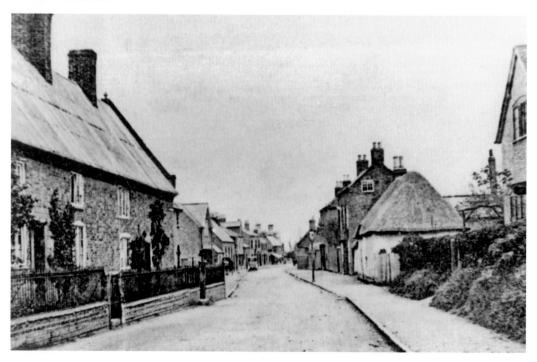

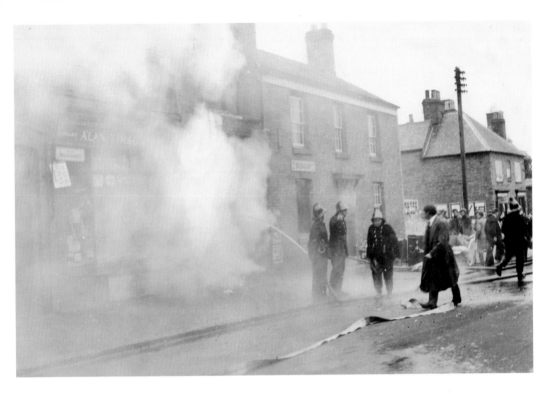

Timpson's Shop on Fire

A fire at Mr Alan Timpson's Lending Library at 47 High Street also affected the Barratt's shop next door at No. 45. No. 47 was later converted into a private house and then back into a shop.

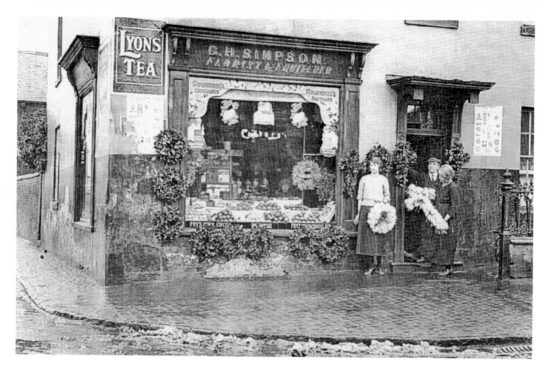

Simpson's Shop

On the corner of High Street and Smeeton Road, many different retailers have occupied this shop over the past 150 years. George Simpson was a frame-work knitter, who prospered sufficiently to set up his own business as a florist and fruiterer. He is standing in the doorway with his wife Maggie.

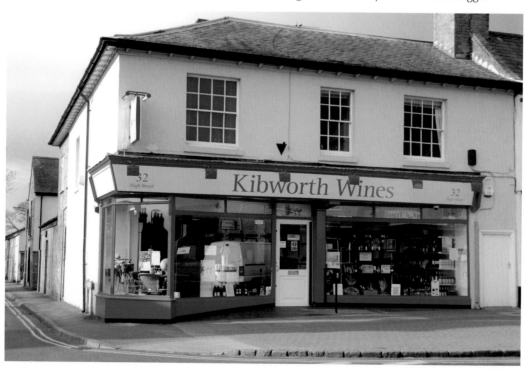

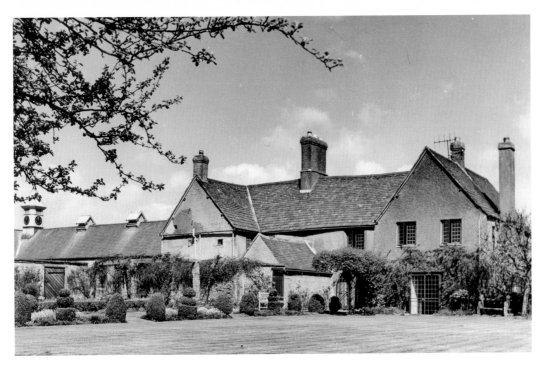

The Manor House, Kibworth Beauchamp
This lovely house may be one of only two H-shaped Elizabethan dwellings still surviving in the country. It dates to the late 1500s, but has some eighteenth-century alterations. This photograph is by the late Bert Aggas and was taken in the 1970s.

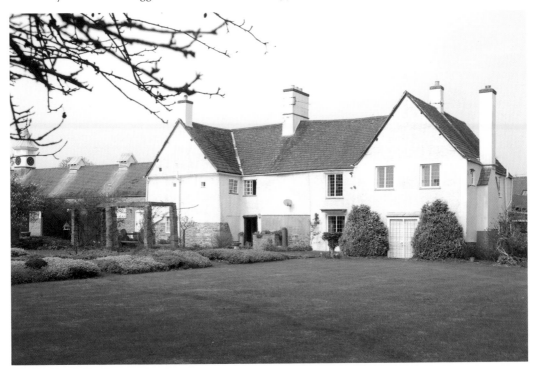

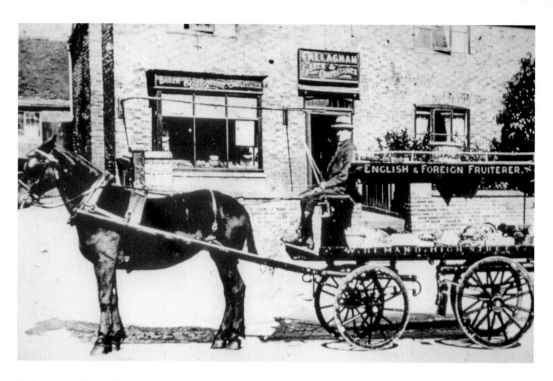

Callaghan's Shop, High Street
Mr Callaghan was a baker and confectioner, who baked his own bread at the rear of his premises. The alley or jitty which led to his yard was located where the deli now stands.

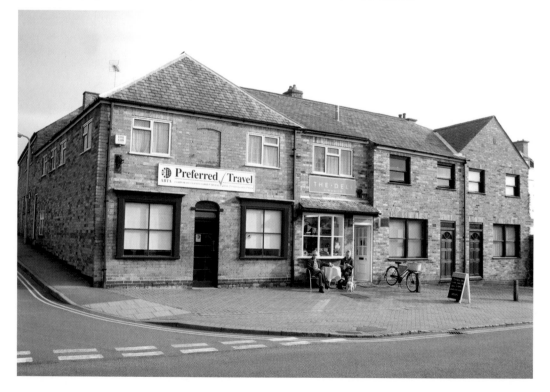

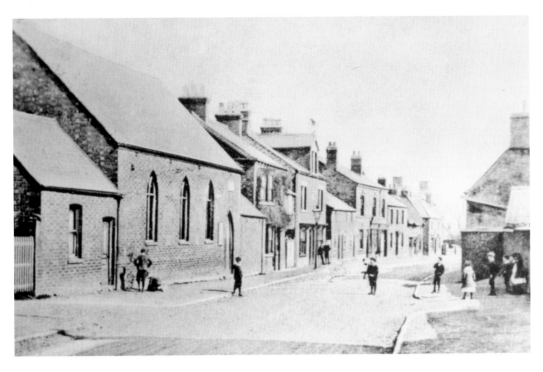

Baptist Chapel, Fleckney Road

Over 700 people signed a petition opposing the demolition of the old Baptist Chapel, which is now owned by the Co-op. The Baptists met formerly in an outhouse belonging to Beauchamp House. It was later used by the Parish Church as a hall, before the construction of the new hall next to the church.

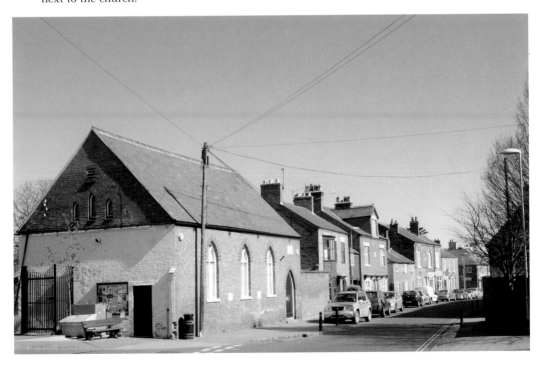

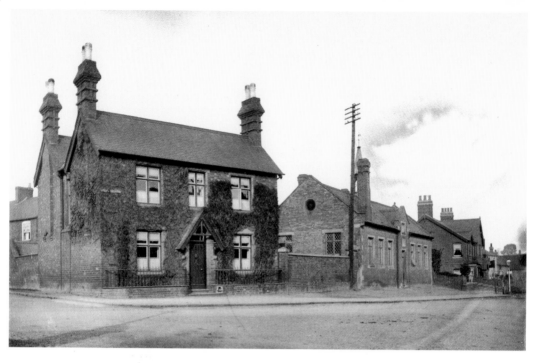

The Schools on The Bank

The Schoolmaster's house, built in 1842, dominates the view. The National School on the right, founded in 1812 and rebuilt in 1842, now serves the community as a Health Centre for a local GP practice.

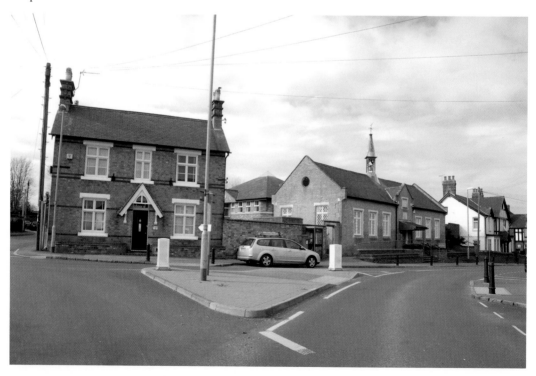

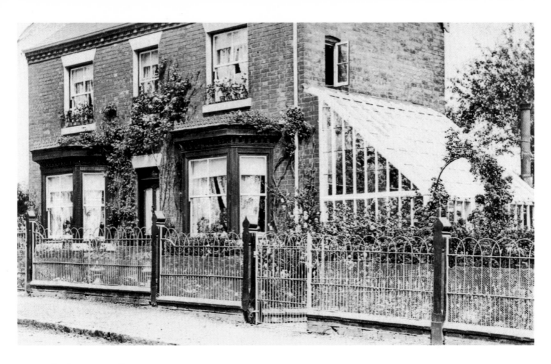

Fleckney Road Cottage

This is a fine example of an earlier cottage which has survived into the twenty-first century. Much of the original building has been retained but the railings were probably sacrificed during the Second World War.

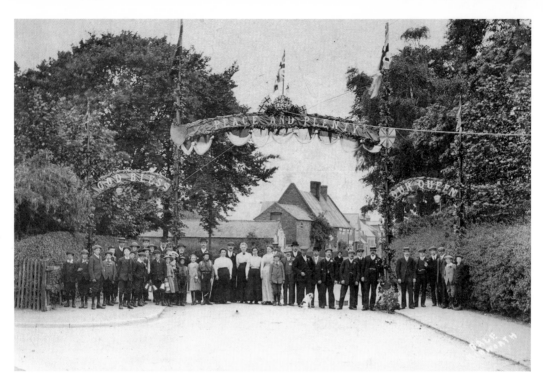

Coronation Celebration – King George V and Queen Mary
This is Fleckney Road looking towards the centre of the village from Rosebery Avenue. The occasion may be the Coronation of King George V and Queen Mary of Teck on 22 June 1911.

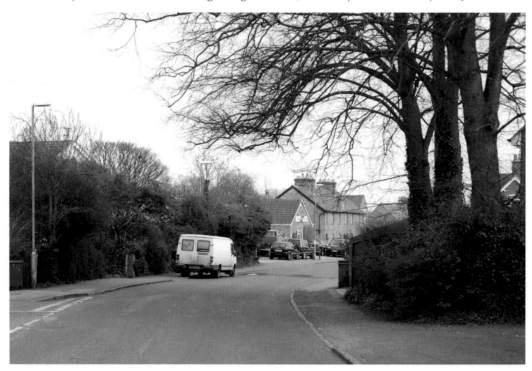

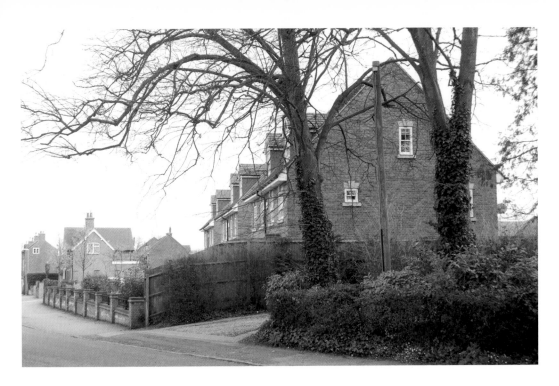

Southlands, 6 Fleckney Road

Southlands, formerly known as Newton's House and built in about 1902, stands to the right. Set in its landscape of trees, it was once the home of one of Kibworth's eminent physicians, Dr Edgar Phillips, and was where he held his surgery and ran his dispensary. The site is now a development of thirteen new dwellings.

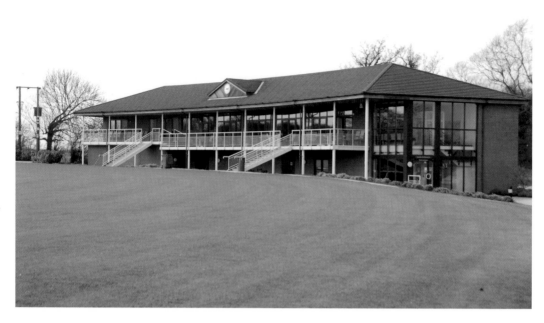

Kibworth Cricket Club
Kibworth has a long and impressive record in cricketing history. Here is one of the club's award-winning first elevens from more than a hundred years ago. Recently, the club has been able to construct a superb new clubhouse and ground which is the envy of many larger clubs.

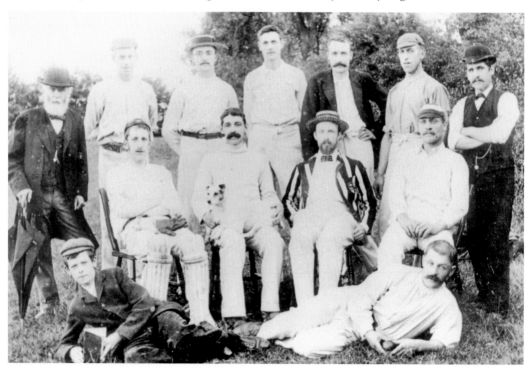

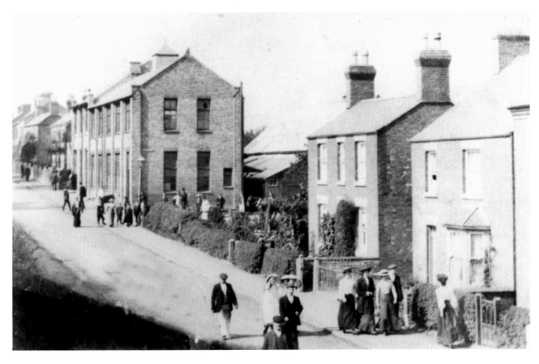

Johnson & Barnes, Fleckney Road
Built in 1901, this was one of two power-driven hosiery factories in the village. It ceased production in the early 1960s. An important source of employment, at its heyday more than four hundred local people worked here.

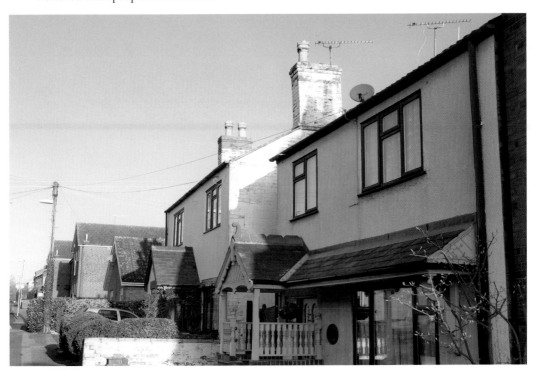

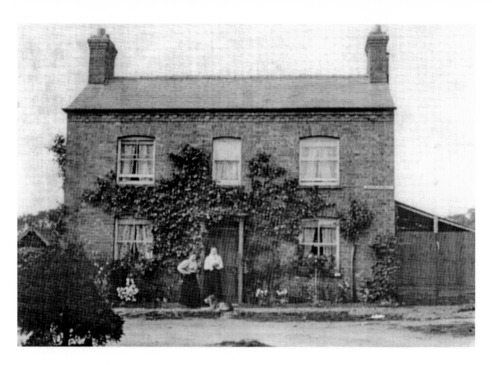

Rose Cottage, White Street

Rose Cottage was built by William Bird, who moved to Kibworth as a corn merchant in 1880. Two of his family are in this photograph which dates to 1901. This delightful cottage was originally the first building in White Street, which now extends into Meadowbrook Road.

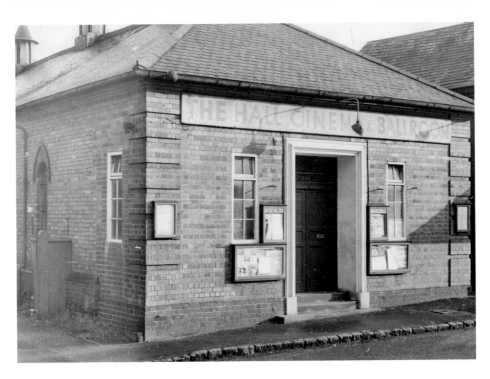

Village Hall, Beauchamp

Beauchamp's Village Hall can hardly be described as an attractive building, or as a good example of late-Victorian architecture, but it has been at the heart of the community for more than a century.

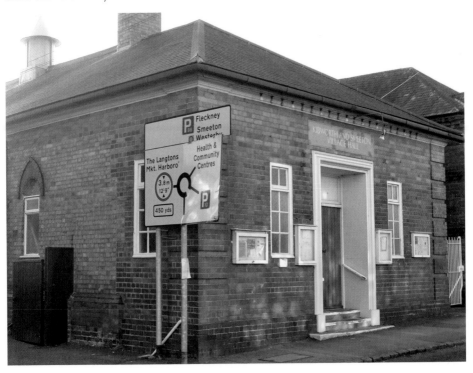

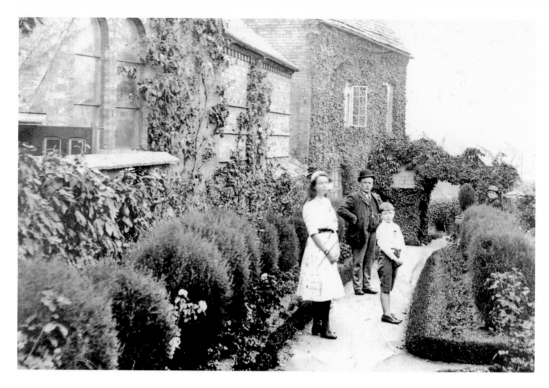

Stuart Court

The view is the side of the village hall looking towards Station Road, and today it is not a pleasant sight! The context of the older photograph is that of the garden of Stuart House, which now serves as the Warden's House of Stuart Court, home to a number of retired Church of England clergy. *Inset:* the side of the village hall.

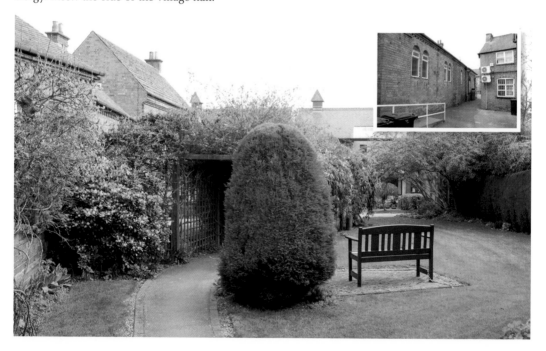

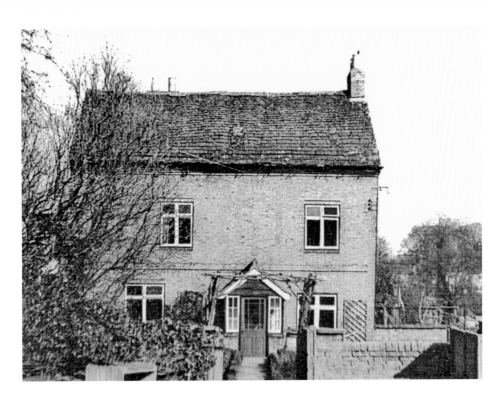

Stuart House

Stuart House is one of Kibworth's hidden architectural gems. It contains a carved beam, which has been dated to 1627, and a stone chimney of the same date. The house itself was rebuilt in brick in the eighteenth century. It is now part of the imaginative Stuart Court development. The gardens and terraces are delightful.

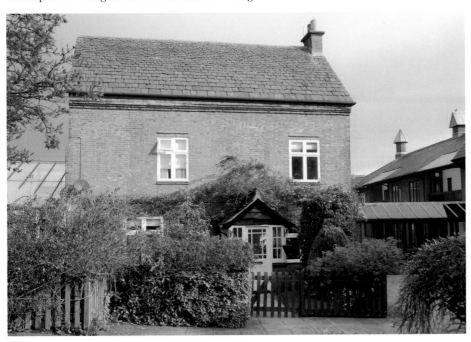

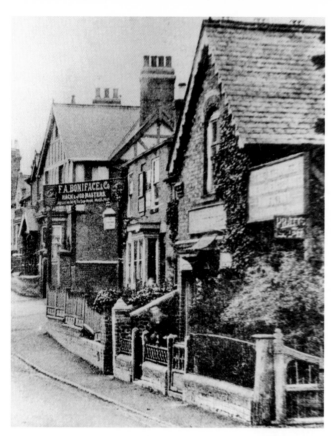

The Railway Arms and Freeland's
A photograph of Alonzo Freeland's chemist shop, probably taken by Freeland himself in about 1905, showing the earlier Railway Arms. The placard advertises Frederick Boniface, who stabled some of his horses and carriages behind the inn as an offshoot to his main business in Weir Road.

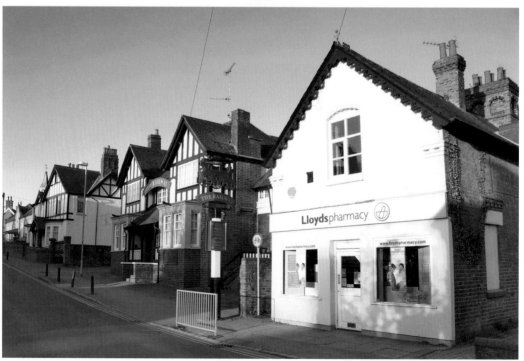

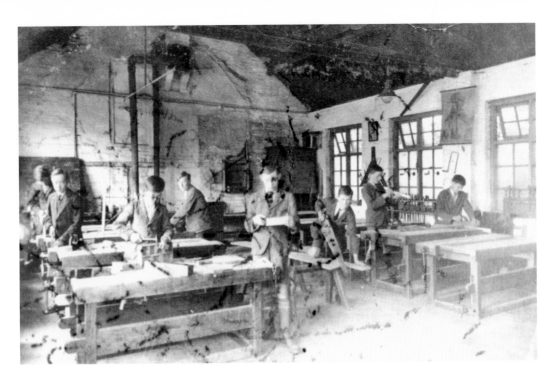

The Grammar School – Classroom
A woodworking class in progress at Kibworth Grammar School. Several of the school's classrooms were built as external annexes to the main buildings. This particular room has since been demolished, but the girls' needlework and domestic science area has survived, converted tastefully into a residential dwelling.

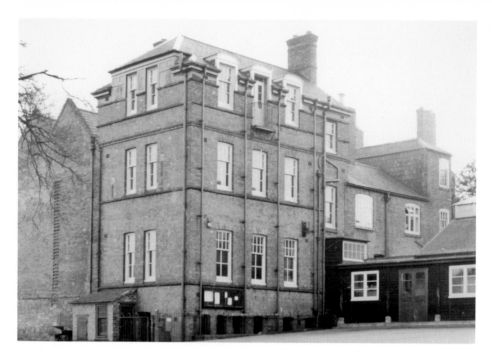

The Grammar School I

Kibworth Grammar School has a long and impressive heritage. The earliest document relating to the school is a charter dating to 1359; but tradition has it that the school was founded by Richard Neville (1428–1471), also known as Warwick the Kingmaker. The Beauchamp family were also the Earls of Warwick, and Neville married a Beauchamp heiress.

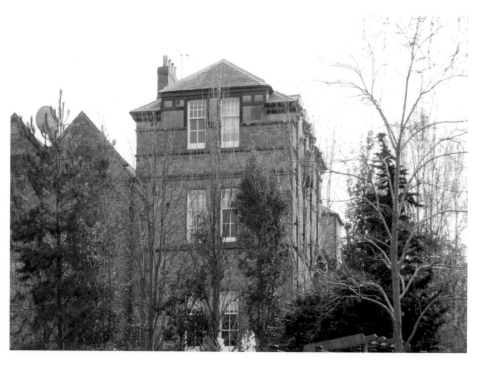

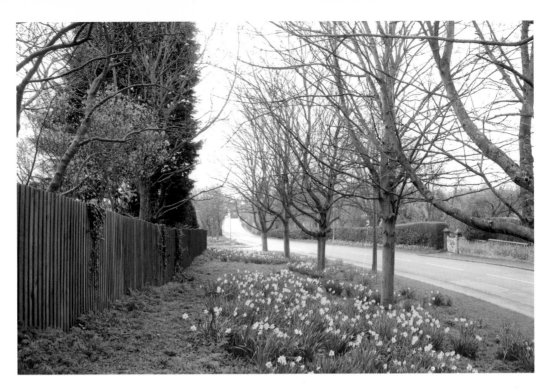

Down Church Hill

The Bank is in the far distance. When the railway was built, it is possible that a level crossing existed to the left of where the road and bridge now stand. The route downhill to the crossing may be the present path which slopes down to the Rookery Close recreation area.

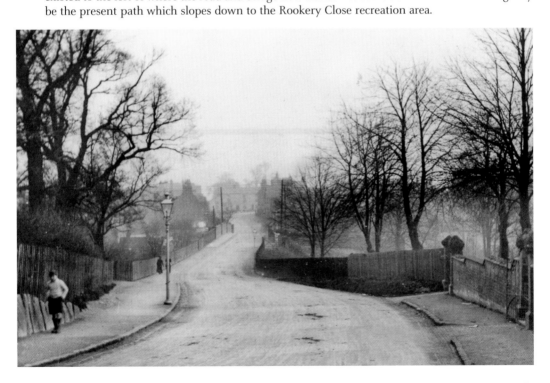

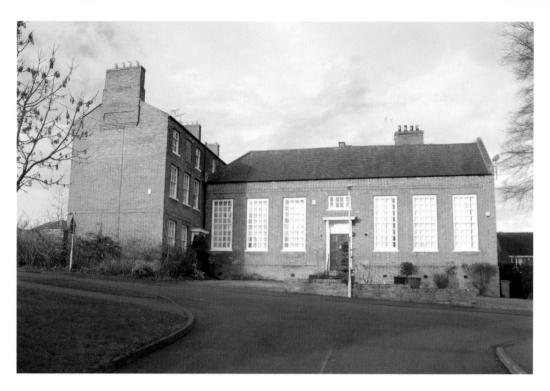

The Grammar School II

The tall trees, which are so evident in this photograph by the late Bert Aggas, were removed when the school building was converted into residential accommodation. It was built in 1725. It replaced an earlier building, which was located some fifty yards away.

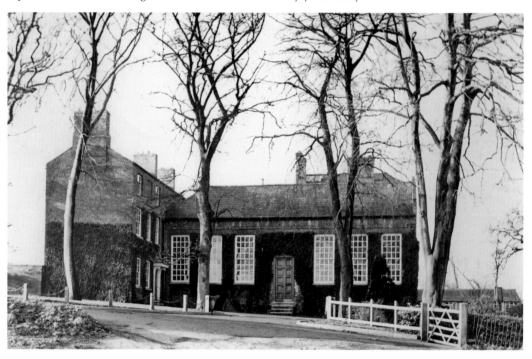

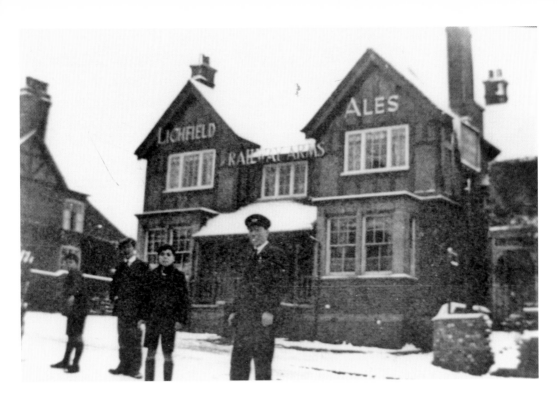

The Railway Pub

This popular pub has been through several reincarnations, including changes of name from 'tavern' to 'inn', and now to simply 'The Railway'. It was probably a private residence until the railway was built. For some time until about 1885, the Reformed Methodists met in a small building inside the inn's yard, which, given the Methodists' view on alcohol, must have been a somewhat uneasy relationship.

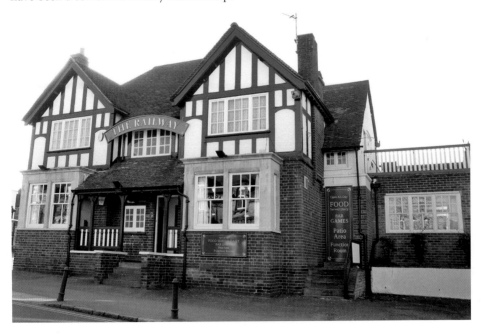

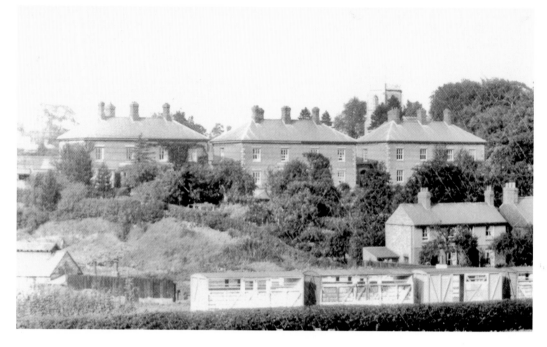

The Villas

The earlier photograph was taken from near the old Grammar School and shows the railway line in the foreground, then 'Little End', which is now Station Hollow, can be seen and, dominating the skyline, the substantial dwellings of The Villas. Legend has it that these houses were built by a wealthy doting father for his offspring. Possibly, the valley in which the houses of Station Hollow now stand is the oldest area of settlement in Beauchamp.

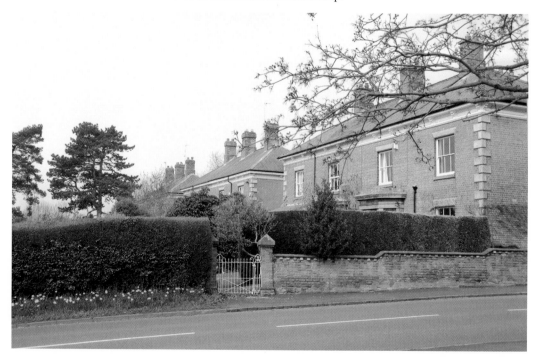

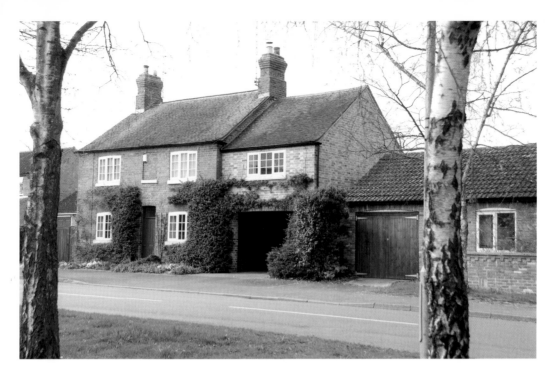

Curate's Cottage
Residential development on this side of Church Road has rendered this cottage less visible, but once it stood alone, opposite the church. According to F. P. Woodford, it was built by the Revd Montague Osborne, who was the rector between 1851 and 1854, for his parish clerk, and it later served as Beauchamp's first post office.

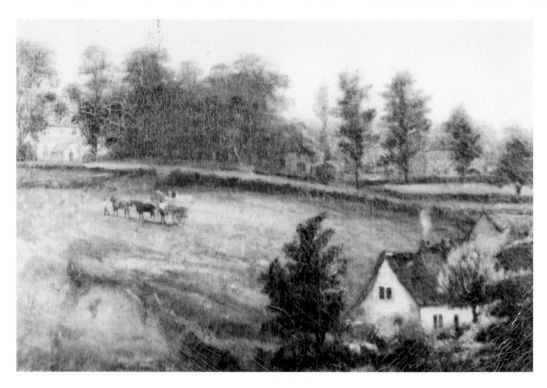

The Church and Little End

A romantic impression of the landscape towards the church with what is now Station Hollow in the foreground. The rectory of 1788 is on the right of the picture. There is still some rough pasture land between the railway line and modern residential development. Today, the view is dominated by The Villas.

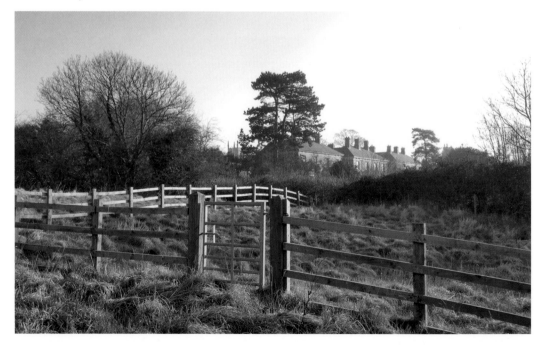

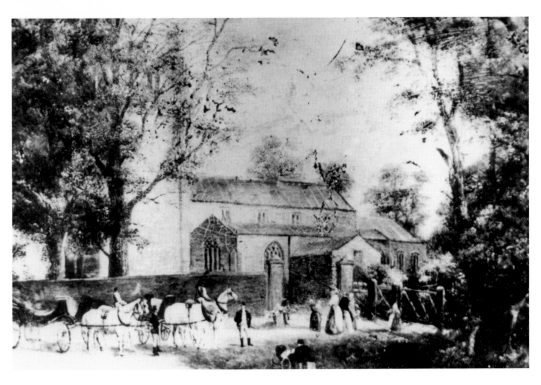

St Wilfrid's Parish Church
A painting of a possible wedding party outside the parish church. The brick wall was constructed soon after the collapse of the spire.

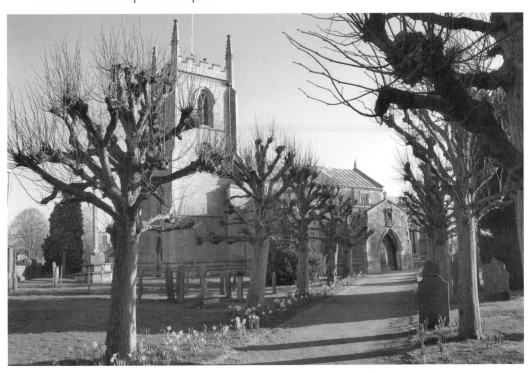

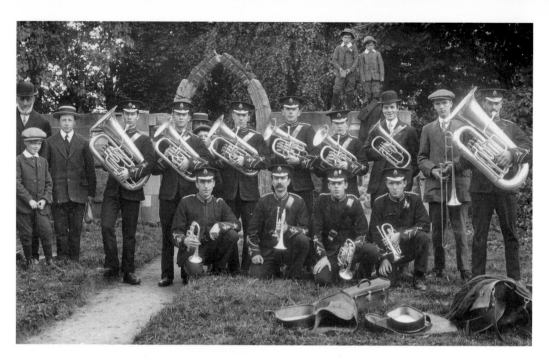

The Kibworth Band at the Ruined Church of St Nicholas, Knaptoft
Local brass bands still play at outdoor services at Knaptoft on summer Sunday mornings. Since this photograph was taken, the reconstructed part of the arch in the background has been removed.

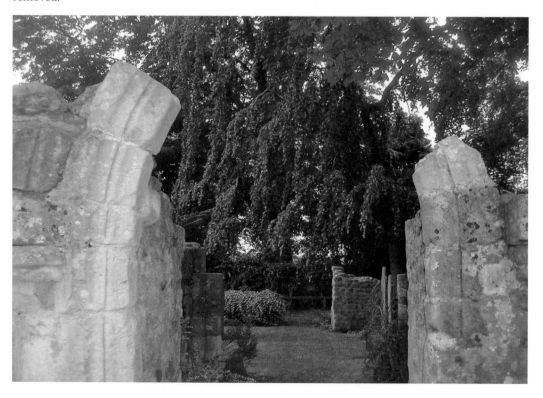

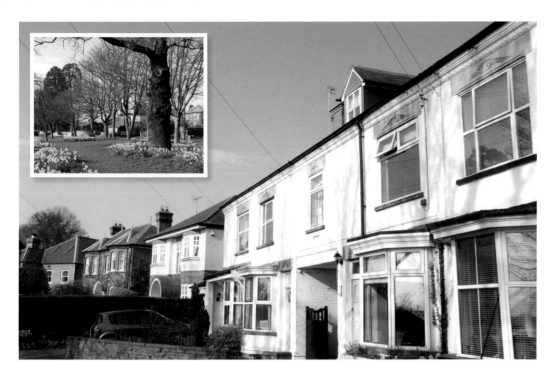

Smeeton Road I

The sharp bend in Smeeton Road just after its junction with High Street is no more. A pleasant island of spring bulbs provides a screen for the older houses. It is possible that the tree in the older photograph has survived as one of the older trees on this island.

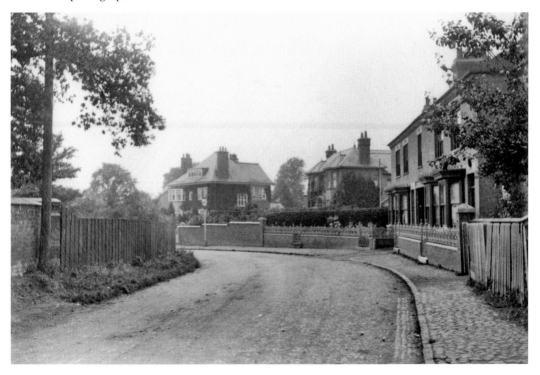

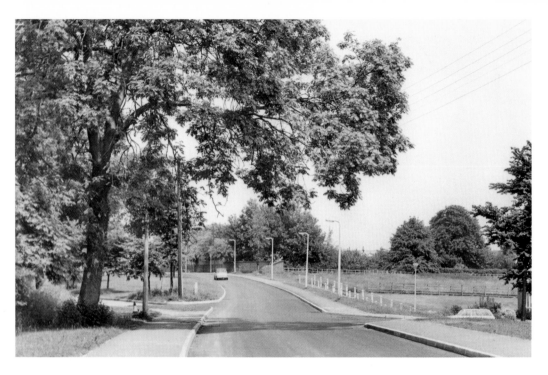

Smeeton Road II

The same view from the Smeeton direction looking towards Beauchamp. The health centre is now on the land on the right, originally part of Kibworth Beauchamp manor's lands. The manor garden's retaining wall can just be seen in the older photograph.

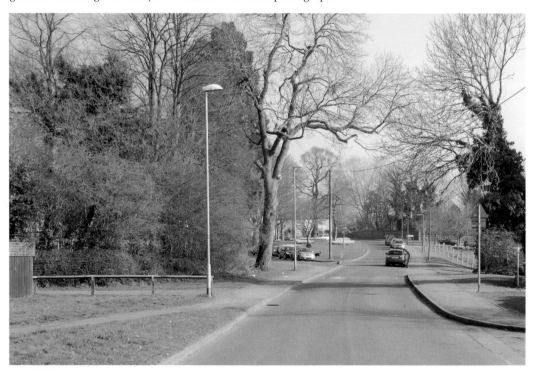

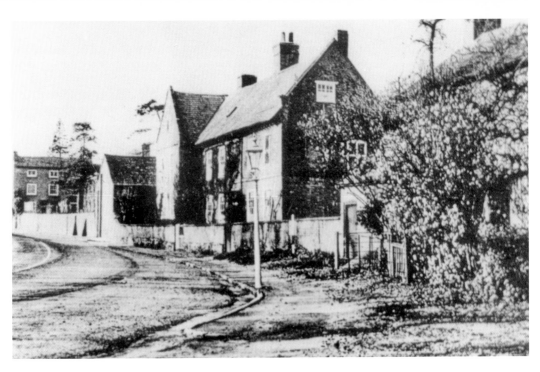

Paddocks Farm, Leicester Road

Numbers 69 and 71 Leicester Road were built as one building in 1704, and are still owned by Merton College. The college monogram can be seen inscribed on a stone built into the perimeter wall.

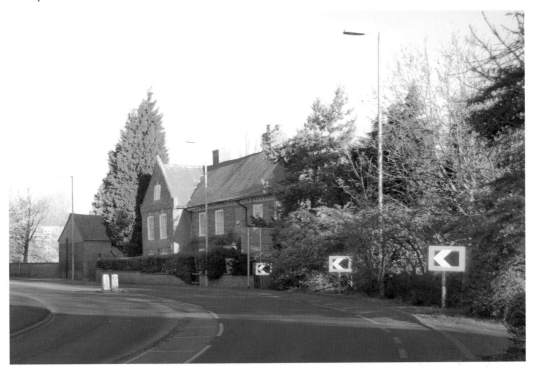

The Rose and Crown

Perhaps Kibworth's most well-known coaching inn, the former Rose and Crown has been a landmark on the main Leicester Road since the eighteenth century. In its heyday, up to twenty coaches stopped here each day.

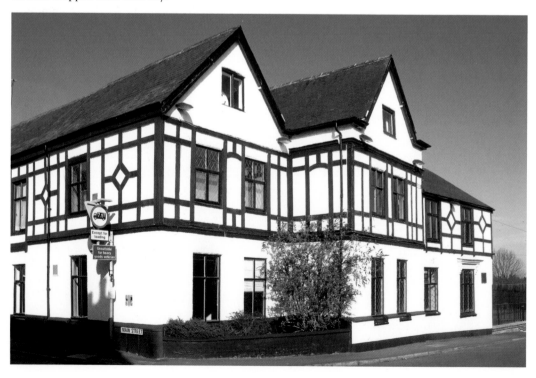

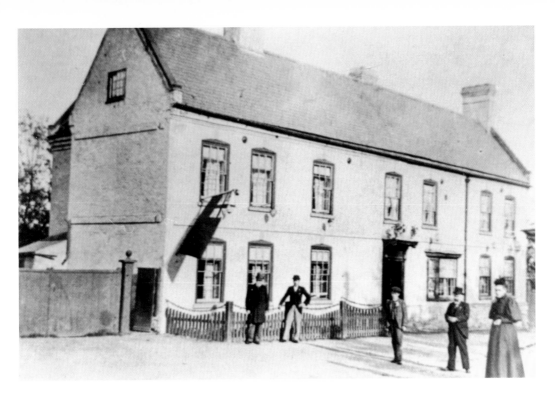

The White House

Standing on Leicester Road, the White House is a building with a fascinating and somewhat mysterious history. It was the home of the famous Dissenting Academy of Revd John Jennings, who also instituted the nearby Congregational chapel. It was later The Crown, another coaching inn, and coaches would pull up in the yard at the back to offload their passengers and goods. It is also said that the house is haunted.

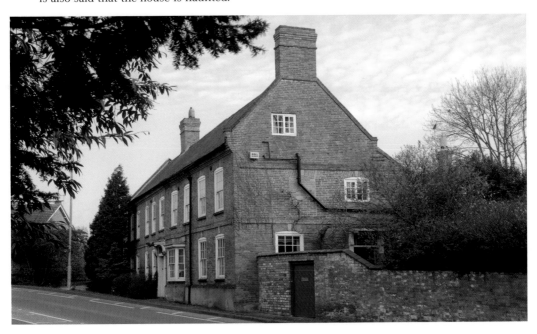

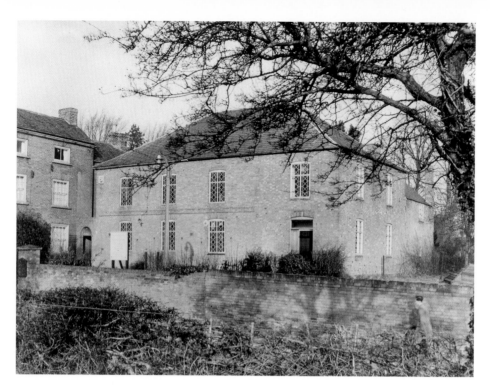

The Congregational Chapel

Instituted in 1662, the history of this place of worship reaches back to the Act of Uniformity and the consequent 'great ejection' of ministers from the established church. The hymn writer Dr Charles Doddridge worshipped here, having been a student, later master, of the nearby academy. It closed as a place of worship in 1997, and was converted into a private residence.

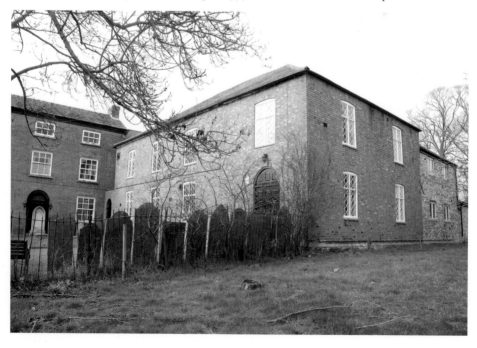

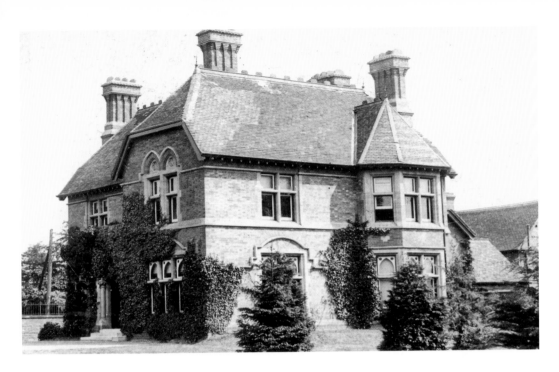

The Gables

The imposing mid-Victorian lines of The Gables, the last house in Beauchamp on the Leicester Road, are now hidden by trees and woodland. A camp housing Italian prisoners-of-war was built during the Second World War on the land behind The Gables. In 1944, British parachutists, who were later to be deployed at Arnhem, were housed in Nissen huts at the camp.

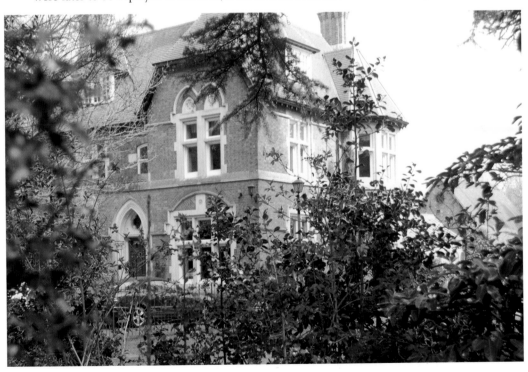

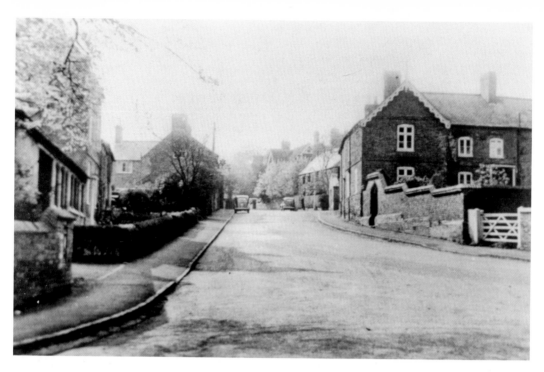

Main Street, Harcourt

Main Street was the main route through Kibworth until the present road – the A6 Leicester Road – was built in 1810 at the cost of £1,500. The first passenger coach travelled along Main Street in 1744. Its twists and turns were a notorious hazard for less-experienced coachmen.

Main Street, Harcourt

A view of the junction of Harcourt Terrace and Main Street. On the right, a narrow path leads to the historic (and still rather mysterious) Munt, and on across to Leicester Road.

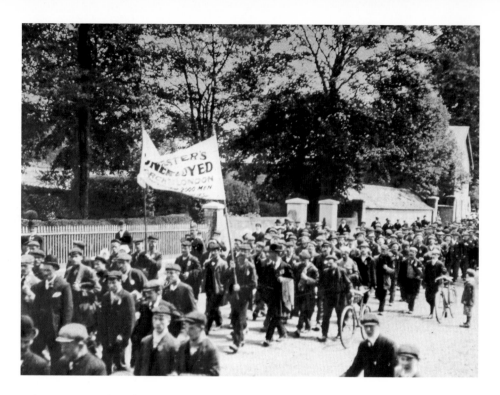

Leicester Unemployed March

In June 1905, some 450 or more unemployed men from Leicester marched to London. One of their leaders was the Revd Frederic Donaldson of St Mark's Leicester, known as the 'vicar of the unemployed'. On their return, on Sunday 18 June, they marched through Kibworth. Supporters on bicycles had ridden out from Leicester to greet them. Interestingly, this photograph of the marchers passing the church indicates that the men detoured through Beauchamp rather than staying on the main road.

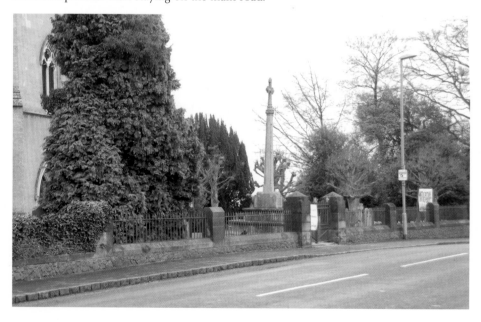

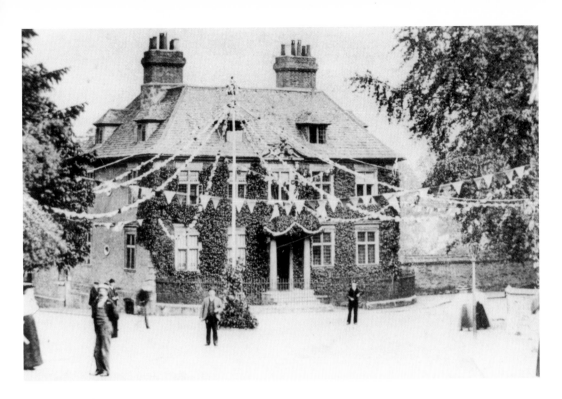

The Old House

William Parker, whose family had lived in Kibworth for at least five generations, built the Old House in 1678. It was later acquired by an attorney, Thomas Peach, and may have been associated at some time with the nearby Dissenting Academy. In the twentieth century, its most famous occupant was General Jack, a distinguished First World War soldier.

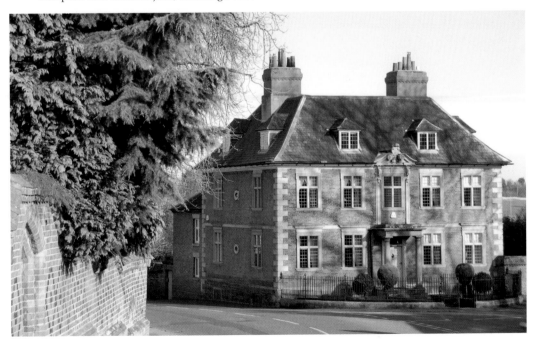

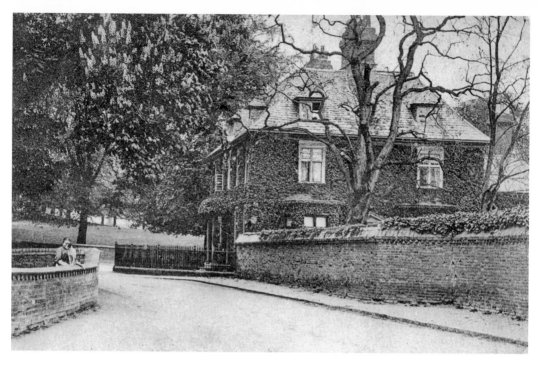

The Old House

A view of the Old House from near Harcourt Terrace. In the eighteenth century, the house had no front garden. It is said that the owner at the time enclosed the area in order to keep noisy children away from his front door.

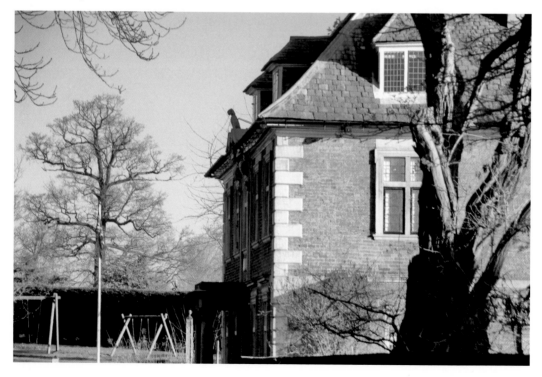

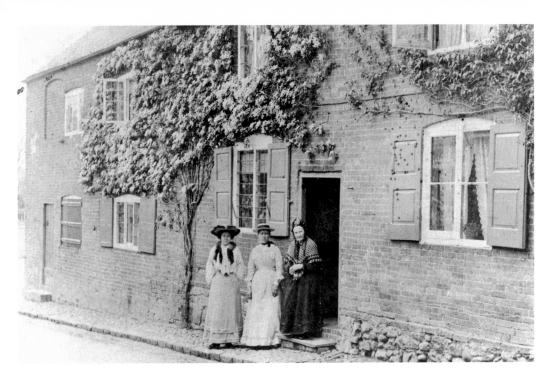

Harcourt Cottage

Kibworth had numerous inns in previous centuries. There were no less than three in Main Street. Harcourt Cottage was once the Navigation Inn.

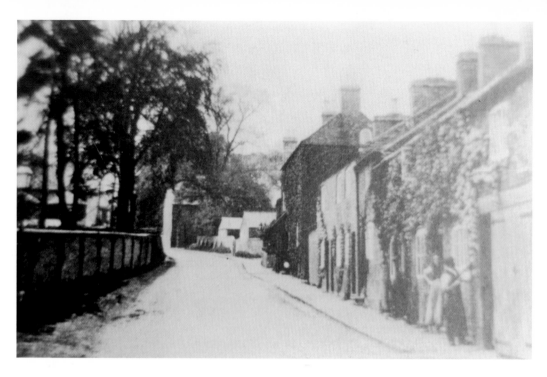

Harcourt Farm, Albert Street

The ivy-clad Harcourt Farm dates from 1787. The old barn, in the distance where the road curves, has been converted to residential use. The retaining wall on the left is associated with the Old House.

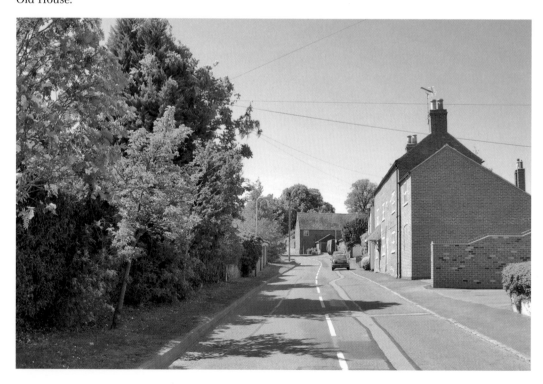

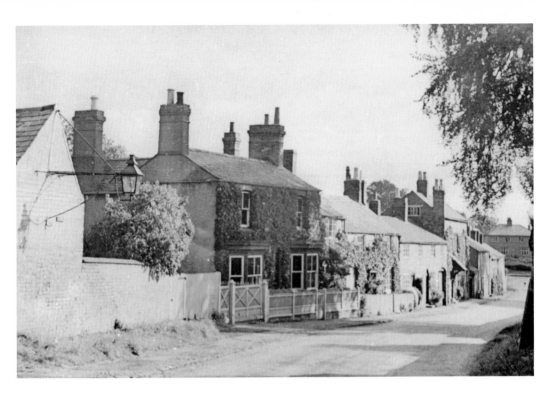

Main Street to Albert Street
Looking towards the Carlton Road junction where Harcourt's market was once held. The road drops down to where a brook once crossed, which often flooded the nearby properties. On the right is part of the old walled garden which belonged to the Old House.

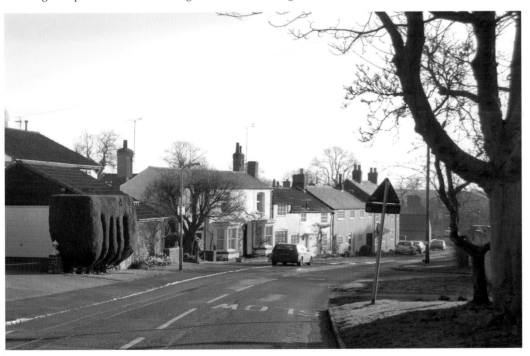

Albert Street near The City
Despite modern development, there is a feeling of continuity in these two images, perhaps because of the continued use of red brick as the predominant building material.

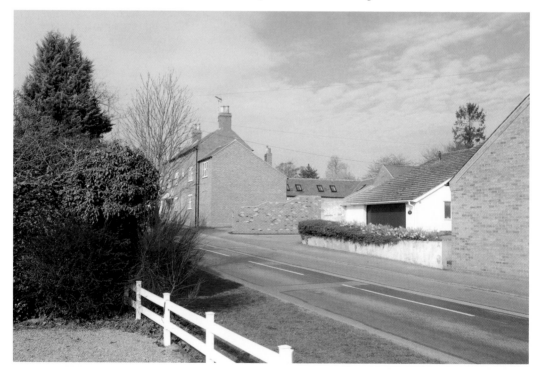

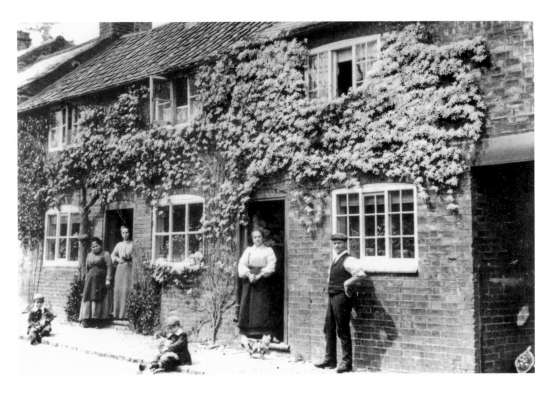

Carlton Cottage

The white frontages of these cottages shine in the early morning sunshine. In earlier times, this was Hog Lane. The slope of the road down to the brook nearer the Carlton Road turning is evident.

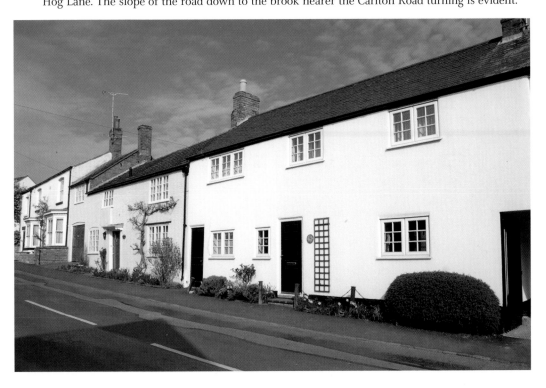

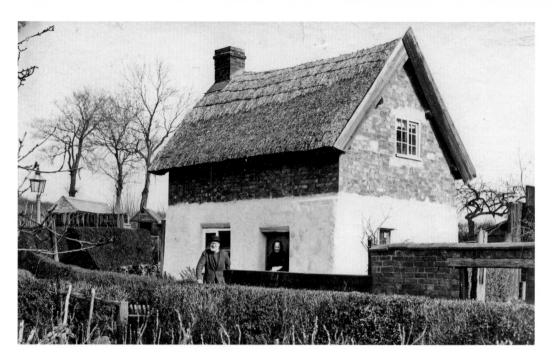

No. 1 The City

The origin of the name for this collection of little dwellings behind the Carlton Road is still debated. It is thought that it is derived from a rhyming slang word for the state of the nearby Hog's Lane, now Albert Street, after the pig market had taken place. This house was demolished in the 1940s and was one of several mud-cottages in the row.

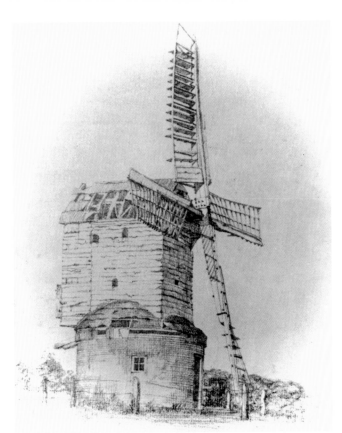

The Windmill
Leicestershire's last remaining
post mill. It dates from the
early eighteenth century and
was working until about 1916.
The most recent phase of
refurbishment began in 1970.
Local tradition says that this
mill was moved here from
another location on rollers.

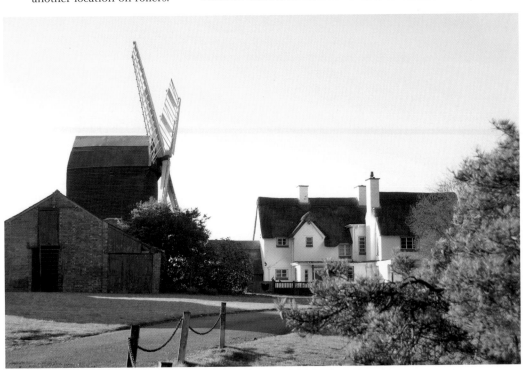

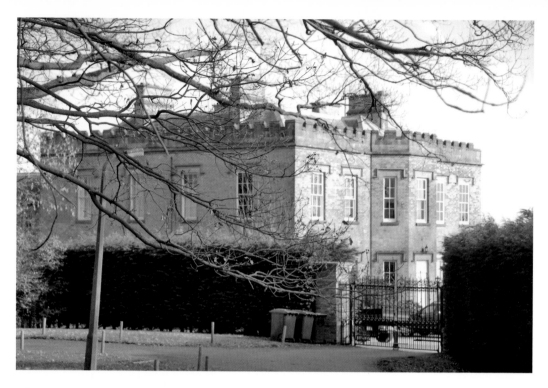

Kibworth Hall

A dignified country house built in 1825. It was owned for many years by the Humphrey family and later served as an approved school for girls and as a hospital. The line of the Carlton road, which skirts the hall's boundary, was re-routed at some time in the past. The earlier route was further away from the hall's present gates.

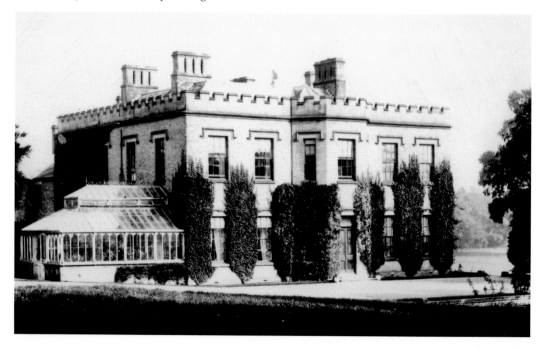

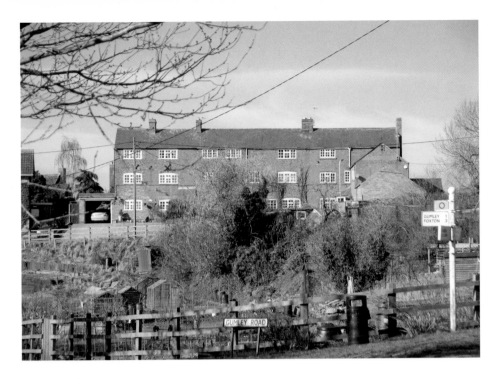

Pit Hill and Smeeton Terrace

Smeeton Terrace stands above Pitt Gardens. For some part of its history it was a workhouse, probably built early in the nineteenth century and later divided into separate dwellings. The existence of large windows on the top floor suggests that at some period it was later adapted for the use of framework-knitters, as in 1844 there were no less than 140 frames in the village. A two-storey workshop is built out at right angles to the main block.

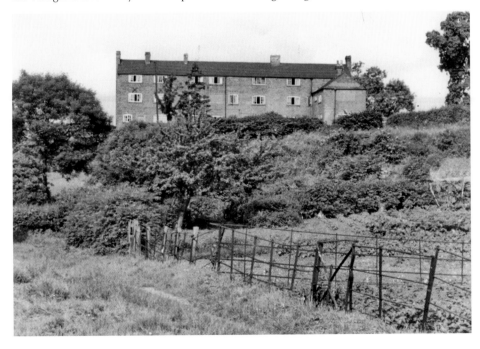

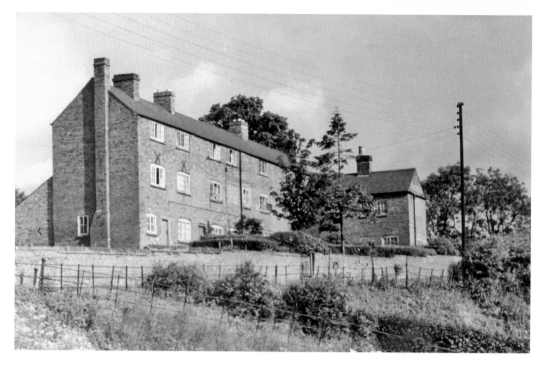

Pit Hill, Smeeton

Below the terrace are the allotments or Pitt Gardens, created when sand was extracted from the site in about 1886. Before that time, a number of mud and thatch cottages stood here. There was another gravel pit east of the church.

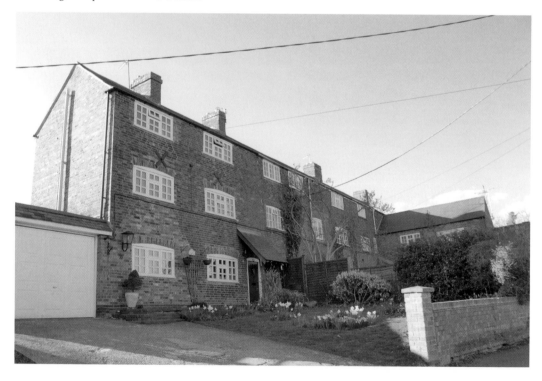

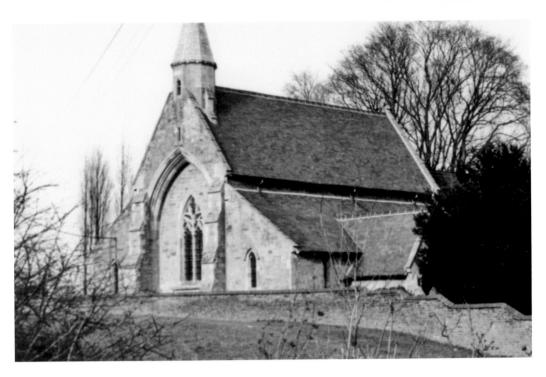

Christchurch, Smeeton

Although in an earlier architectural style, Christchurch was built in the middle of the nineteenth century. The large arch in the west wall suggests that at some time in the planning stages, a tower had been considered.

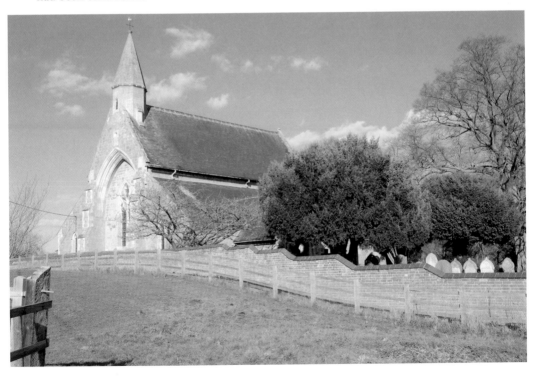

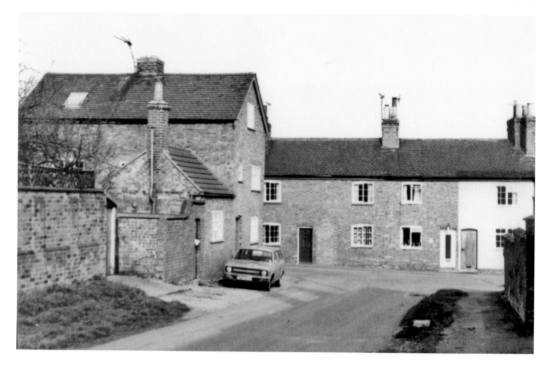

Mill Lane, Smeeton

The King's Head pub stands at the junction of Mill Lane and Main Street in Smeeton, just to the right of these photographs. Some of the buildings here date back to the seventeenth century. A windmill stood just south of here, which was blown down in about 1885 with the miller inside it, according to F. P. Woodford.

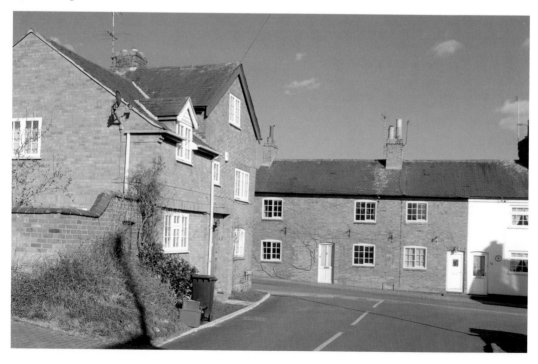

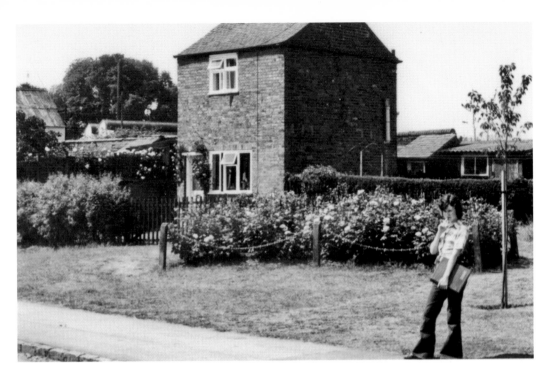

Village Green, Smeeton

Possibly one of the smallest village greens in England, but the villagers plant bulbs and the children plant flowers here. It is located in the centre of Smeeton and respects ancient boundaries, but may not have been used as a green until relatively recent times.

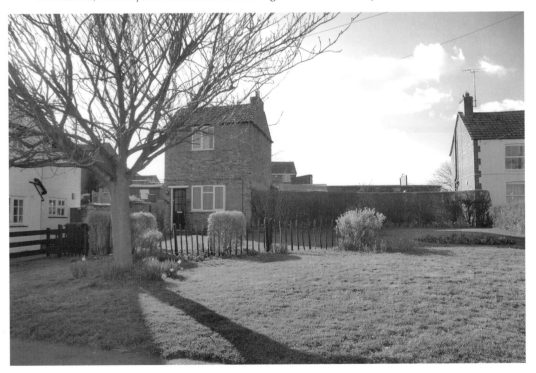

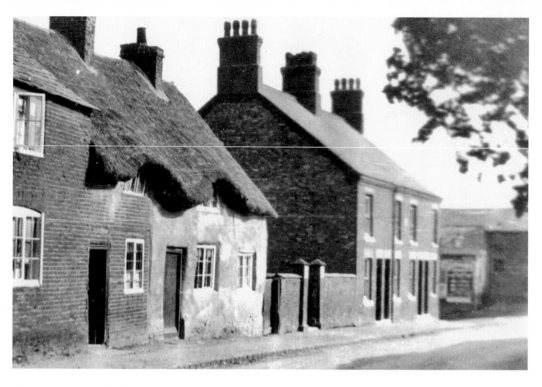

Smeeton, near Debdale Lane

The Coronation Cottages near to the turning for Debdale Lane remain, but the thatched cottage has gone. Set back from the road, and out of sight, is the village hall, once the National School, and for some years a chapel for various Nonconformist groups.

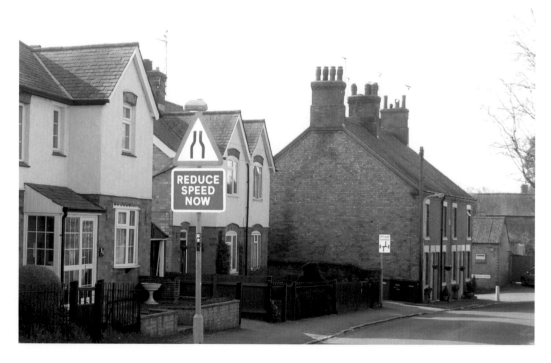

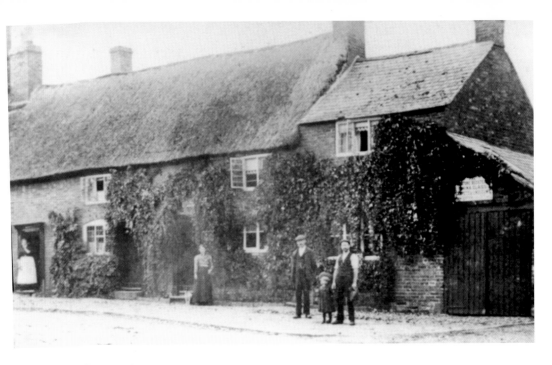

The Old Forge, Smeeton

On the corner of Blacksmith's Lane, Smeeton's smithy closed in 1902, when Robert Smalley was the blacksmith. Next door was the village's first sub-post office.

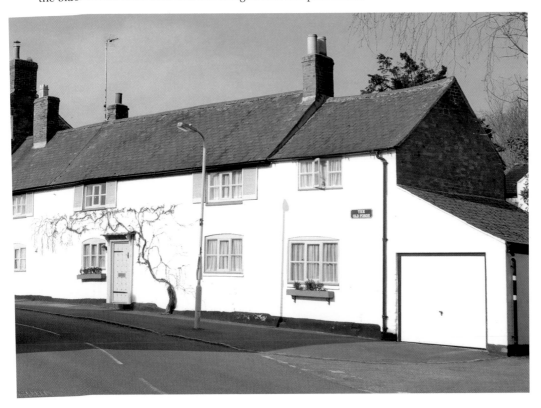

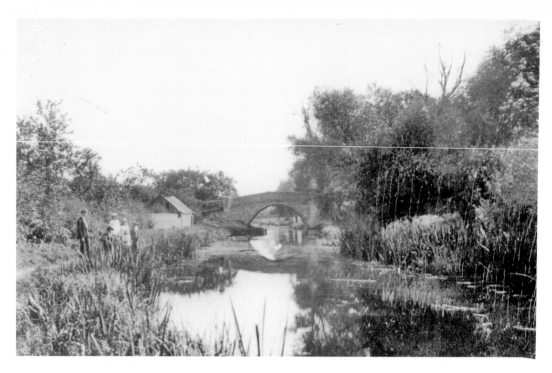

Debdale Wharf

An afternoon's walk from Smeeton, Debdale was the end of the canal for some years as the (Grand) Union Canal Company found itself in financial difficulties and could not proceed as originally planned. The canal was open to this point in April 1797, but it was not until October 1809 that the route through to Market Harborough was continued. The present bridge (No. 65) was rebuilt in 1922.

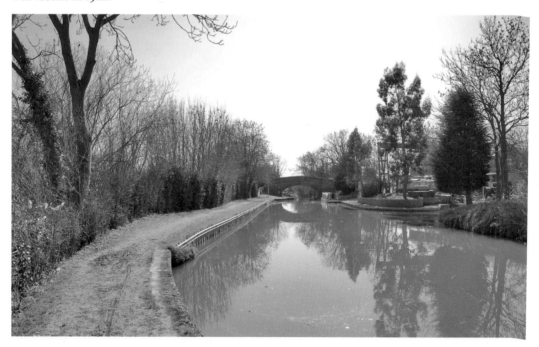